photographing
Martha's
Vineyard

Where to Find Perfect Shots and How to Take Them

Alison Shaw

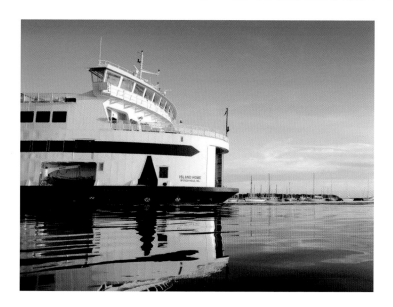

THE COUNTRYMAN PRESS

WOODSTOCK, VERMONT

For my partner, Sue Dawson,
who has made it possible for me to pursue
my photographic dream job.

Also, for my workshop students,
past, present, and future.

Maps by Paul Woodward, © The Countryman Press
Book design and composition by S. E. Livingston

Photographing Martha's Vineyard

ISBN 978-0-88150-942-7

Published by The Countryman Press,
P.O. Box 748, Woodstock, VT 05091

Distributed by W. W. Norton & Company, Inc.,
500 Fifth Avenue, New York, NY 10110

Printed in the United States by Versa Press, Peoria, IL

10 9 8 7 6 5 4 3 2 1

Title Page: Ferry **Island Home,**
Vineyard Haven Harbor
Right: South Beach

Acknowledgments

Thank you to Sue Dawson, Jan Pogue, and Nis Kildegaard for editing and proofreading this first-time writer's text, Neil Chaput de Saintonge for making sure my technical information is correct, and Claire Cain for her office and production work. Also to Kim Grant for inviting me to write this book, and to Philip Rich and Lisa Sacks of Countryman Press for such a pleasant experience in guiding this book to completion.

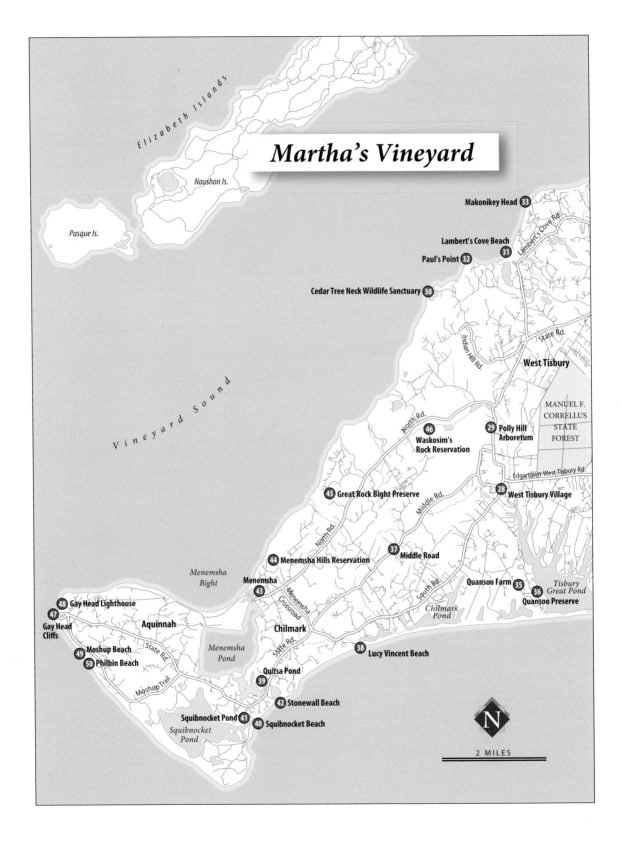

Martha's Vineyard

Elizabeth Islands

Naushon Is.

Pasque Is.

Makonikey Head **33**

Lambert's Cove Beach **31**

Paul's Point **32**

Lambert's Cove Rd.

State Rd.

West Tisbury

Cedar Tree Neck Wildlife Sanctuary **30**

Indian Hill Rd.

MANUEL F.
CORRELLUS
STATE
FOREST

North Rd.

46 Waskosim's
Rock Reservation

29 Polly Hill
Arboretum

Edgartown-West Tisbury Rd.

45 Great Rock Bight Preserve

North Rd.

28 West Tisbury Village

Middle Rd.

37 Middle Road

Vineyard Sound

*Menemsha
Bight*

44 Menemsha Hills Reservation

Menemsha **43**

Menemsha
Crossroad

South Rd.

Quansoo Farm **35**

*Tisbury
Great Pond*

36 Quansoo Preserve

*Chilmark
Pond*

48 Gay Head Lighthouse
47

Gay Head
Cliffs

Aquinnah

State Rd.

*Menemsha
Pond*

Chilmark

State Rd.

38 Lucy Vincent Beach

49 Moshup Beach
50 Philbin Beach

Moshup Trail

Quitsa Pond

39

42 Stonewall Beach

Squibnocket Pond **41**

40 Squibnocket Beach

*Squibnocket
Pond*

N

2 MILES

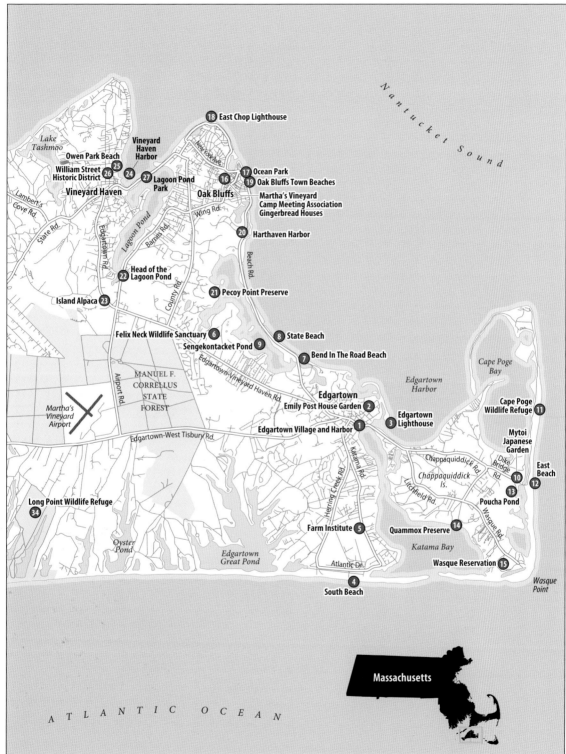

Lake
Tashmoo

18 East Chop Lighthouse

**Vineyard
Haven
Harbor**

Owen Park Beach

William Street
Historic District **26** **25** **24** **27** Lagoon Pond
Park

Vineyard Haven

Lambert's
Cove Rd.

State Rd.

17 Ocean Park

16 **19** Oak Bluffs Town Beaches

Oak Bluffs

Martha's Vineyard
Camp Meeting Association
Gingerbread Houses

New York Ave.

Wing Rd.

Lagoon Pond

Barnes Rd.

Edgartown Rd.

County Rd.

20 Harthaven Harbor

Beach Rd.

Head of the
Lagoon Pond **22**

Island Alpaca **23**

21 Pecoy Point Preserve

Felix Neck Wildlife Sanctuary **6**

Sengekontacket Pond **9**

8 State Beach

Edgartown-Vineyard Haven Rd.

7 Bend In The Road Beach

Edgartown
Harbor

Cape Poge
Bay

MANUEL F.
CORRELLUS
STATE
FOREST

Airport Rd.

Martha's
Vineyard
Airport

Edgartown **Edgartown**
Emily Post House Garden **2**

Edgartown Village and Harbor **1**

3 Edgartown
Lighthouse

Cape Poge
Wildlife Refuge **11**

Chappaquiddick Rd.

Dike
Bridge
Rd.

Mytoi
Japanese
Garden

Chappaquiddick
Is.

10 East
12 Beach

13

Poucha Pond

Litchfield Rd.

Wasque Rd.

Edgartown-West Tisbury Rd.

Herring Creek Rd.

Katama Rd.

Long Point Wildlife Refuge
34

Oyster
Pond

Edgartown
Great Pond

Farm Institute **5**

Quammox Preserve **14**

Katama Bay

Wasque Reservation **15**

Atlantic Dr.

4

South Beach

Wasque
Point

N a n t u c k e t S o u n d

A T L A N T I C O C E A N

Massachusetts

Paul Woodward, © The Countryman Press

Gingerbread cottages, the campgrounds

Contents

Stone wall, Middle Road

Introduction

I am lucky to live and work in what I consider to be one of the most photogenic locales anywhere. Yes, anywhere. I've traveled the country and many parts of the world teaching workshops and in search of new photographic subject matter. But each time my feet are firmly planted back on the island of Martha's Vineyard, I realize this 100 square miles of sand, nestled off the south coast of Cape Cod, has as many photographic opportunities as any other place I've visited.

The Vineyard is not nearly as grand as other locales, neither flashy nor precious. It doesn't leave you in awe. Everywhere you look is certainly not a "postcard." It's a quieter beauty, a little more mundane, and sometimes you need to poke around a little to find it. Years ago I was commissioned to photograph the building of a 24-foot wooden sailboat under construction at a bustling little boatyard on the shores of Vineyard Haven Harbor. Over a six-month period I showed up a couple of times a week and recorded the progress of *Maybe Baby*, photographing the warm early morning light bathing the lofting floor, the texture of the rough sawn frames, and drips of a deeply saturated orange lead paint on the planking. Midway through the boat's construction, I interrupted my photography to teach a photography workshop in New Zealand, followed by a couple of weeks

exploring both the North and South islands with my camera. I expected that a month spent halfway around the world in a country renowned for its natural beauty, with nothing more pressing than taking pictures and enjoying a vacation with my partner, would have meant a portfolio of new images that would clearly put my boatyard project to shame. Instead, as I finished shooting the boat through its launch date, I realized my photos of the modest little sailboat were far more artistically successful and creatively fulfilling for me than my thousands of New Zealand images.

Part of the appeal of Martha's Vineyard for photographers is the variety of terrain and subject matter. I don't believe I've ever traveled to another place where so much variety is packed into such a small area. (The Vineyard is 21 miles long, and 9 miles at its widest point. You can drive from the eastern to the western tip in under an hour, including a brief ride on the Chappaquiddick ferry to cross the opening of Edgartown's sheltered inner harbor.) Each of the island's six towns has its own unique character, personality, and history.

Oak Bluffs, formerly known as "Cottage City," has hundreds of colorfully painted Victorian summer houses from the mid-to-late 1800s. Vineyard Haven boasts a wooden boatbuilding industry that would rival any in this country. Chilmark has a picture-perfect working fishing harbor with the best sunset views on the island. In Edgartown you'll find stately white clapboard Greek Revival houses built by the wealthy captains of whaling ships in the 19th century. Aquinnah has a promontory of colorful clay cliffs towering over the ocean at the western end of the island.

The Vineyard also has a diverse community of people. Oak Bluffs is summer home to many of the movers and shakers in the national African American community. Aquinnah has a federally recognized Native American tribe.

The island has a long Portuguese heritage dating back to the heyday of the whaling industry. And the Vineyard regularly plays host to presidents, movie stars, authors, and musicians, here not to be "seen" but because they love what the island has to offer.

An extra bonus: there are many locations for either early morning or late afternoon light. In general, the east coast of the United States has a lot of great sunrise locations, while the west coast is the place to be for sunset. But since we're an island surrounded by water, we've got both.

Because of the island's modest size, great locations are also rarely more than a half hour's drive away. When I teach photography workshops in Maine or in Santa Fe, my students may drive an hour or more to reach a particular location. Here, you can roll out of bed and be at your sunrise destination in no time.

Bend in the Road Beach

Using This Book

This book is written with one thing in mind— exploring Martha's Vineyard from the photographer's point of view. In it I have tried to share my 35-plus years of experience photographing the island. The locations I have chosen should all have merit for the casual or serious photographer. With the more iconic locations, I've tried to include suggestions for looking at them in new, more creative ways. These locations are grouped by town, and begin down-island (the eastern end of the island) and work their way westward to the up-island towns.

In the course of researching this book, I've discovered new locations, which I have now happily added to my list of places I most like to photograph. It has gotten me outside and on location with my camera at all hours, and I hope it will do the same for you, whether you're a year-round resident, frequent vacationer, or first-time visitor.

Mermaid Farm, Middle Road

We are lucky to have an extraordinary amount of conservation land on the island (well over 100 properties open to the public, most of which are owned and managed by the Martha's Vineyard Land Bank), and that acreage increases on a yearly basis. There are also a number of locations accessible only during the off-season, and I have included that information to help you navigate through the seasonal idiosyncrasies of the island.

I've offered up a number of pro tips in the book, most of which can be found in the chapter "How I Photograph Martha's Vineyard." These technical pointers and suggestions have been developed from personal experience in the field and teaching workshop students. Some of this technical advice is geared toward the more experienced photographer, while much of it will be as useful to the vacation photographer.

Since your visit to the island will not be *all* about photography, I've added some non-photographic diversions at the end of each location chapter. Put down your camera and learn some island history, take in a play at an outdoor amphitheater, go for a sail on a tall ship, or eat a lobster while watching the sunset at Menemsha.

There are some weekly and annual signature events on the island with lots of photographic possibilities, and I've chosen to describe them in detail in their own chapter. I've also included a list of my personal favorites, whether sunrise/sunset locations, scenic drives, places to launch a kayak, or restaurant picks. I end the book with a resource list to help with your planning and logistics.

So grab your camera, catch a ferry, and don't forget to take this book along for the ride.

Head of the Lagoon Pond

How I Photograph Martha's Vineyard

I was a "summer kid" on the Vineyard growing up. My grandparents lived in Edgartown, and we'd come visit for a month every summer. After graduating from college in 1975, I came "just for the summer" and never left.

For 25 of those years, I worked as a photographer and graphic designer for the *Vineyard Gazette,* the venerable local black-and-white broadsheet paper with a long tradition of prominently displaying creative photos. Work-

ing for the *Gazette* pushed me to eat, drink, and sleep photography, and gave me the platform to share my photos with its thousands of far-flung readers (from all 50 states).

I learned a couple of important photographic lessons during that time. The first seems pretty obvious: if you're not out there with your camera, you're simply not going to get the photo. A quote from Woody Allen hangs above my desk: "Eighty percent of success is

showing up." When I worked for the *Gazette,* you would never find me without my camera bag in the trunk of my car—there was always enough time to pull over to the side of the road to photograph something that caught my eye. When I teach photo workshops, we meet every morning in the pitch dark to shoot dawn and sunrise. Unless you are *there*—standing bleary-eyed by the side of Seaview Avenue, gazing out over Nantucket Sound, clutching your travel mug of java while steadying yourself with your tripod—you will not have a chance to photograph the fast-moving crescendo of the high clouds catching fire with an orange-magenta glow, rimmed with a purple-blue, as the sun reaches the point right below the horizon.

Another photographic life lesson learned during my tenure at the *Gazette* was the ability to see the same old subject matter anew. Mainland photographers have an advantage—when they get bored with the subject matter in their own town, all they have to do is drive a few miles to a whole new interesting area to photograph. Here, a natural geographic boundary limits such exploration. But I see this as a creative advantage. Rather than simply going farther afield to find something new, I am forced to dig deeper into my own creativity to reinterpret the same subject matter time and time again. It pushes me constantly to see the same subjects in a new light.

The ability to see the island anew each morning felt like part of my job description as a photographer at the paper. After all, wouldn't the readers of the *Gazette* get more enjoyment out of looking at the paper if I was able to capture their favorite island from a new perspective? The same was true for myself. To take the same photo over and over again would have reduced the process to a purely mechanical act. It would have taken all of the art, all of the passion, out of it.

One of my goals with this book is not simply to help you take good, serviceable photos of the island—otherwise known in photography lingo as "record shots"—but to push you to interpret the island in your own way.

Over the years my vision has changed and grown. I've gone from exclusively using black-and-white to color film. This is akin to an artist working with nothing more than a box of charcoals for 15 years, and then being handed a set of oil paints or pastels. I went from more to less compositionally, reaching a point of extreme minimalism. As the years passed, I went from representational to abstract, from vivid primary colors to soft and muted tones, from hard-edge, precisely framed images to a loose painterly style.

While this is not a technical "how-to" book, there are some technical details that I think will be helpful in getting the most out of your photographic experience on Martha's Vineyard. Unlike painting, where anyone can pick up a paintbrush and slap some paint onto a canvas, photography is inherently a more technical art. It is crucial to learn this part well enough so that it is second nature, freeing you to concentrate on the creative. Ansel Adams sums it up perfectly: "You can have craft without art, but you cannot have art without craft."

Equipment

Cameras

My thoughts about equipment apply primarily to the amateur/hobbyist photographer using a digital single-lens reflex (DSLR) camera, rather than to the "point-and-shoot" day-tripper. This is not intended in any way to slight the point-and-shoot variety, since the most basic digital cameras are remarkably good technically, and creativity comes from the photographer and not the gear. If you are looking to purchase a basic DSLR, Canon and Nikon are both great choices.

When it comes to equipment, I'm a real "no-frills" sort of photographer. I used the same Nikon F3 and Pentax 67 film cameras for the fifteen years leading up to my switch to digital just a couple of years ago. I now use the Nikon D700, but still with my prime lenses that date back to the 1980s. The newest, most expensive equipment is not going to make you a better photographer. In fact, it might do just the opposite. I always had this secret wish to make all of my workshop students hand over their fancy equipment for the week and shoot instead with a Pentax K1000 with a 50mm lens—and insist they shoot on manual. In this way they could more easily have learned the basic principles and controls of photography, ultimately freeing them to focus on really seeing.

Lenses

I would recommend investing in several zoom lenses that cover the range from 20 to 200mm. Don't look for a lens that "does it all"—with any zoom lens that covers too big a range of focal lengths you will suffer a corresponding loss of quality. An advantage of zooms over prime lenses is less changing of lenses and therefore less possibility of dust getting into your camera and onto your sensor. Faster lenses (ones which have larger apertures) add significant weight and cost, which you should take into consideration. Don't buy a non-camera-brand lens unless you do some research. Some are terrific while others can be lemons. Sigma and Tamron are good choices for non-camera-brand lenses.

Be aware that lenses behave differently whether you are using a camera with a full-frame sensor or not. A full-frame sensor is the size of a 35mm piece of film. Only a very few of the most expensive digital cameras come with full-frame sensors. In the case of the rest of the cameras with smaller sensors, you will experience a lens magnification factor of approximately 1.5. What this means is that when you are using a 28mm lens, what you will see through your viewfinder will feel more like a 42mm lens. At 42mm you will no longer have that wide-angle "look." In that case, you will probably want to invest in a digital wide-angle lens where your shortest focal length will be more like 12mm.

Some sort of lens stabilization system such as Nikon's Vibration Reduction or Canon's Image Stabilization is a good feature to look for in a lens, since it allows you to shoot hand-held at two to four shutter speeds slower than without it.

If you enjoy close-up photography, you should add a macro lens to your gear.

Tripod

I consider a tripod to be an essential piece of equipment, particularly when shooting in low light, with a long lens, or macro. A tripod also enables you to slow down and carefully compose a shot in your viewfinder. It injects a dose of discipline and meticulousness into your process.

Many people hate tripods because they haven't used a good one. I can pretty much guarantee you'll hate any tripod/head combo that costs under $100. A tripod needs to be sturdy, and tall enough so that you don't have to hunch down to use it. There are lots of new hi-tech materials being used now to make tripods that are extremely solid but also much lighter. Manfrotto makes some terrific inexpensive tripods. You'll need to purchase a head separate from the tripod—I would recommend getting a ball head with a quick-release plate.

I own two Gitzo carbon fiber tripods (a larger one for shooting on the island and a smaller one for travel or for long hikes), with a Kirk Enterprises ball head (BH-3) with a quick-release plate and an "L" bracket that easily and quickly enables me to switch back and

Farm Neck daisies

Filters

forth between shooting horizontal and vertical. Since I have such a great set-up, I enjoy my tripod rather than considering it a pain to use.

Filters

Since switching to digital, I have reduced the number of filters I use down to practically nothing. One filter that cannot completely be duplicated in a digital darkroom is a polarizing filter. A polarizer is a great tool to help add saturation to your images by rotating the filter to reduce reflections and glare. The effect is one that is easier to achieve in-camera at the time of digital capture. For that matter, anything that can be done in-camera and not in Photoshop or Lightroom will mean more time in the field and less time staring at the computer screen.

The only other filter I carry is a skylight (also known as a UV or haze) filter. It's important to note that I don't use a skylight filter unless I need it to protect my lens—think salt spray, snow, rain, or blowing sand.

I no longer carry split neutral density filters, once a staple in my camera bag, since the same effect can be replicated in the digital darkroom.

Accessories

As for other important equipment, here's a short checklist.

Try to get in the habit of always using a lens shade to cut down on any stray light entering your lens. This is particularly important with zooms, composed of so many elements of glass that more light bounces around the reflective surfaces. A lens hood is also essential when photographing in the rain or snow.

A cable release is handy for shooting at slower shutter speeds when your camera is on a tripod. A longer lens or a rickety tripod creates potential problems when manually operating the shutter release, making a cable release even more important. If you don't have one, for most situations you can use your self-timer instead.

One of the coolest accessories designed for digital cameras is a loupe made by Hoodman. It's made to be placed right up against your LCD display so that you can more easily view your image. Before I discovered this gadget, I used to spend a lot of time ducking into a shady spot or throwing a jacket over my head in order to better view an image on my LCD when shooting outdoors in bright sunlight.

Tech Tips: Camera Set-up, Shooting

I can't overstress the importance of spending a small but crucial amount of time getting your digital camera set up properly before venturing out to shoot. I wish someone had helped me with these settings when I was new to digital and new to my first hi-tech camera—it would have saved me a lot of time and aggravation. That said, these settings and suggestions are not designed for every photographer or every camera—they are simply intended for you to bring consciousness to your technical decisions concerning your camera. These tips are aimed primarily at the photographer shooting with a DSLR.

• **Image quality:** Your most important decision is image quality, JPEG vs. RAW. In fact, all digital cameras actually capture the image in RAW, but if you've set your image quality to JPEG, your camera will instantly make a bunch of adjustments to your image to make it look presentable. On the other hand, if you shoot in RAW, you'll need to make those adjustments later on using Lightroom or similar software.

If you're really serious about your photography, you should probably pick RAW. It will give you the best possible starting point. It's also a lossless format, which means no matter how much work you do on your image, you will not be altering or affecting the pixels themselves. The downside is that since you'll be starting with a "raw" file, you will have to make all of your own adjustments and improvements to your photo.

If you choose JPEG, be sure you are shooting the highest quality, JPEG Fine. Another choice is to shoot both RAW and JPEG, which might sound like the perfect solution. But do you really want *two* copies of every single photo, when it is a snap to convert your RAW images to JPEGs later on?

Once that big decision is made, the rest of the settings should fall into place pretty easily. I'll provide you with a quick overview and not a detailed explanation—for that, you can buy a technical how-to book.

• **White balance:** If shooting RAW, choose Auto White Balance. If shooting JPEG, there are lots of ways to affect white balance—you can make your photo warmer, cooler, or neutral by playing with your white balance settings.

Stonewall Beach

- **ISO:** Select the lowest ISO your camera allows, unless you have a good reason to change it (don't forget to change it back). With many of the latest camera models you can set your ISO considerably higher and still get great quality. Never leave your ISO on Auto.

- **Exposure mode:** I'd recommend Aperture or Shutter Priority. Personally, I choose to shoot in Manual—it's kind of like driving a stick shift, in that it puts *you* in charge.

- **Metering:** Matrix or Evaluative, not Spot or Center-weighted.

- **Drive mode:** Single Shot, Continuous, or Self Timer—pick the one that is appropriate to what and how you're shooting.

- **Auto-Focus mode:** Set according to whether your subject is still or you are following action. There are times you will need to shift to Manual focus, including when you have a very low-contrast subject or in low light conditions.

- **Playback display:** Turn on Histogram and (Blinking) Highlights.

- **File Number Sequence:** On.

- **RAW Compression:** Off.

- **Long Exposure Noise Reduction:** On.

- **High ISO Noise Reduction:** On.

- **Compact flash cards:** Always have plenty of cards with you—especially if you are shooting RAW, since the file size is so large. Turn your camera off to change cards. Always reformat (do not simply delete images), but don't reformat until your images are backed up in at least two locations.

- **Batteries:** Keep one in your camera, one in your camera bag, and one in the charger.

- **Judging exposure using your histogram:** Evaluate your exposure based on the histogram, not on how your image looks on the LCD. The horizontal axis of your histogram is a measure of tonal value with black on the left end, white on the right end, and medium tone in the middle. Your histogram should reflect the tonal values in the scene you are photographing. Be careful about "clipping" the right end of your histogram, which means your highlights will be blown out—refer to your Blinking Highlights to determine where in your image the clipping has occurred.

- **Checking focus on your LCD:** Enlarge image to check focus.

- **Changing lenses:** Turn your camera off and face it downward, so as to reduce the possibility of attracting dust.

- **Mirror Lock-up:** Use this to eliminate vibration when your camera is on a tripod and you are using a long lens at slower shutter speeds.

- **Depth of field preview button:** This is useful for checking actual depth of field when you are shooting at any aperture except wide open. The results will be easiest to see when using a telephoto lens to photograph a scene that contains both foreground and background elements.

In the Field

Scouting a Location

I find that in locations such as Menemsha, where there's a lot to photograph, it can take quite a bit of poking around to find something that catches my eye. I often scout an area like this before I get out my gear. If you're laden with equipment, laziness tends to set in—there is a tendency to photograph the *first* lobster buoy (or fishing boat, or wildflower) you come across, rather than the *best* lobster buoy. By "scouting" I mean doing a lot of walking and really looking. Climb onto rocks, look under

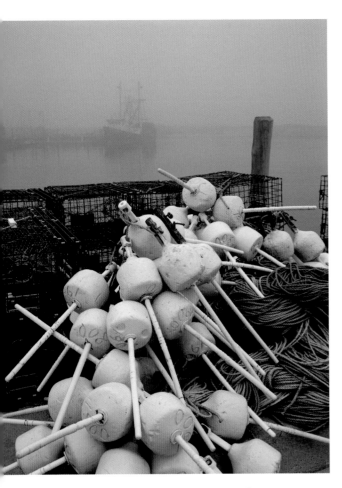

Lobster traps and buoys, Menemsha

docks, go around corners, or walk to the end of the jetty. Pick out a few spots that you'd like to explore further with your camera. Only then, with a plan in mind, should you grab your camera bag and your tripod.

Working a Subject

This can mean spending a lot of time trying to see your subject in different ways, and/or going back often. It means not taking the obvious shot, or the first shot that presents itself. You should be looking for the best shot, which takes some effort and hard work. I once had a student who shot six rolls of 35mm black-and-

white film of Menemsha in the course of an afternoon, and *every* photo was of a different scene. My assignment for him the next day was to shoot a full roll of each scene he selected, and in the course of the 36 exposures to "work" that scene. Shoot it as a vertical or horizontal, with great depth of field or with shallow depth of field, with a wide-angle lens or a telephoto lens; lie on the ground and look up or get up high and look down. In some cases your initial instincts may have been spot on, in which case it will be your first photo that succeeds. In other cases that very process of working a scene may net you a better photo.

Using a Tripod

Used properly, a tripod can be a big asset to your photography. Faulty tripod set-up is probably the number-one source of frustration faced by my students in the field.

First, be sure everything is screwed down as securely as possible—there should be no wobble at any juncture. Start with making sure the quick-release plate "becomes one" with your camera.

Don't use any center-post extension until you've run out of leg extension, since the legs are more stable than the center post.

Don't be lazy when using your tripod—just because you start with the legs at a certain height doesn't mean that this will remain the ideal height for every subject you shoot.

In windy conditions, I often drape my camera bag over my tripod and let the bag hang down around the legs—the added weight helps to stabilize the tripod. During the exposure, I stand so that my own body is shielding the tripod from the wind.

Aperture and Shutter-speed Choices

If you are shooting with a DSLR and choose to set your exposure mode on Program or Auto, you've basically taken a very expensive camera

and turned it into a point-and-shoot. Whether you choose to shoot on Aperture Priority, Shutter Priority, or Manual, you should always be conscious of *both* your aperture and your shutter speed. Do you want a lot of depth of field, or shallow depth of field? Do you want to stop action or show motion? I tend to avoid the in-between apertures and shutter speeds—I generally don't want to have something be a "little" out of focus, or to have the waves moving a "little" bit. If I'm going for blur in my shot, I make sure it's far enough out of focus that my intent is clear. Commit to what you want to say and how you want to say it, and make the corresponding technical decisions to support your vision.

Composition and Creativity

Simplify

The essence of a good composition is reducing a scene to its necessary elements. This means both paying attention to what excites you in a scene *and* being aware of all the other details. Eliminate anything that detracts from what attracted you to a scene in the first place—what you leave out of a photo is just as important as what you put in.

Compositionally speaking, painting is an additive process while photography is a subtractive process. A painter begins with a blank canvas, while a photographer begins with the visual clutter of reality. Yet the painter and the

Red boat, Owen Park Beach

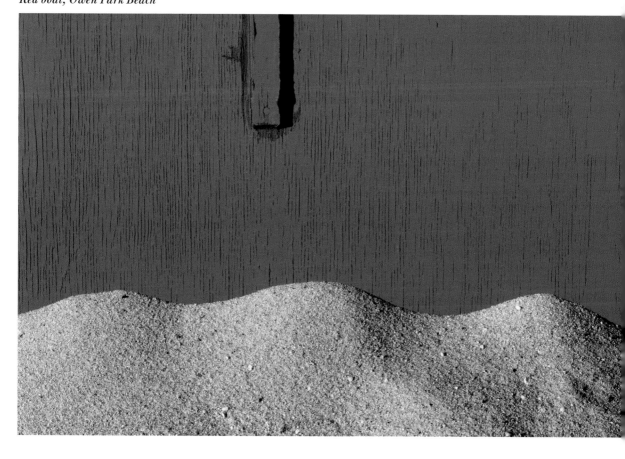

photographer ultimately arrive at the same point.

As you work to simplify your composition, don't go too far. Simplifying doesn't necessarily mean fewer elements in your photo; there is a fine line between a photo that is "simple" and one that is boring. Photographer David Middleton expresses this point perfectly: "A bad photograph is like a paragraph. A good photograph is like a sentence. A great photograph is like a phrase." When I read this quote to my students, leaving out the last word, they inevitably assume that "word" will complete the sentence, but then come to understand that perhaps a single word can be *too* simple, whereas a phrase will be more interesting.

Techniques for simplifying your photo might include isolating a portion of your scene, coming in closer, using a longer lens, choosing a larger aperture to give you shallower depth of field, or changing your vantage point. Watch for distractions around the edges of your frame. Use a tripod so you can compose a scene more carefully.

Push Yourself Creatively

For me, the single biggest advantage of going digital has been the ability to "play" with my camera. Gone are the days when you had to worry about wasting film. Take chances, loosen up, do wild and crazy things with your digital camera, and then check out the images on your LCD and decide what works.

Try putting your camera on the ground and shooting, or hold it (carefully!) out of your kayak at water level. Shake your camera during an exposure. Do an 8-frame multiple-exposure where you move your camera slightly for each exposure. Use your camera like a paintbrush, or put your entire scene out of focus. You might stumble on something that gets your creative juices flowing or at least pushes your photographs somewhere beyond the postcard.

How to Photograph . . .

Sunrise and Sunset, Dawn and Dusk

Since Martha's Vineyard is an island, with scenic views of the water at every point of the compass, there are an abundance of both sunrise and sunset locations. In general, my favorite sunrise locations are down-island, while my favorite sunset locations are up-island.

I'd like to dispel the misconception that dawn/sunrise and sunset/dusk are basically the same experiences, simply in a different order. From my perspective, I'd take sunrise almost any day over sunset (except for the part where I have to get out of bed in the dark). For one thing, there's the "wow" factor, being there for the start of the new day—somehow going from pitch dark to the colors of Oz holds more bang for the buck than doing the whole thing in reverse. Beyond the metaphysical, there are some specific advantages that sunrise offers the photographer. There is a greater chance of significant moisture in the air at sunrise—that's why they call it "morning" mist and "morning" dew. There's also a better chance of flat calm or light wind conditions at sunrise. Mist, dew, and calm winds can take a drab scene and make it much more evocative.

In order to photograph the dawn or dusk sky properly, you must either start in nearly total darkness, or end in darkness. This means being on-location and ready to press the shutter 45 minutes before sunrise, or staying until 45 minutes past sunset. If you're at the end of a long day and have "what's for dinner?" on your mind, it's sometimes difficult to stay the course after sunset. The sunset-watchers at Menemsha usually pack up their stuff and leave as soon as the sun dips below the horizon, missing the peak color that often comes later in the evening. I tell my students that if they didn't need a flashlight to find their way back to the car following a sunset shoot, then they didn't

Oak Bluffs town beach

stay long enough. Don't forget your tripod for dawn and dusk photography, since you will be shooting at slower shutter speeds.

If there are high clouds, they can light up dramatically and sometimes unexpectedly when the sun is below the horizon. These conditions can often produce a blaze of short-lived color.

At dawn or dusk, photographers tend to spend about 99 percent of their time and energy looking in the direction of the rising/ setting sun. But what's going on in the opposite sky is often more interesting, more subtle. When the sky is clear, take a look over your shoulder before sunrise or after sunset and notice the band of blue at the horizon—this is the earth's shadow on the atmosphere.

Once the sun has risen, or before it sets, you have wonderful warm light, known as the golden hour or magic hour. The closer to sunrise or sunset you are, the warmer the color of the light. This warm transmitted light juxta-

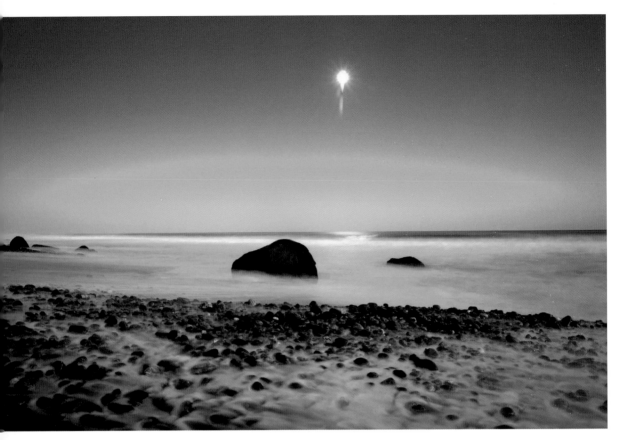

Moonrise, Lucy Vincent Beach

poses with the cool reflected light found in the shadows, creating a tapestry of orange and blue hues.

The Moon

Including the moon in your photo can be akin to adding an exclamation point at the end of a sentence. It definitely spices it up. While you might stumble across the moon by sheer dumb luck, I'd suggest becoming a little more conscious of the cycles of the moon and how you can use that knowledge to make your photos more interesting.

To photograph a scene with the full moon, you're apt to get a better photo on the evening before the full moon, just as Ansel Adams did in one of his most iconic photos, "Moonrise over Hernandez." On the night of the actual full moon, the moon rises close to the same time that the sun sets, often making it difficult to get a properly exposed photo of the risen moon together with sufficient ambient light on your scene. By the same token, the ideal day to photograph the setting of the full moon is usually on the morning *after* the actual full moon. As the relationship between the rising/setting full moon and the rising/setting sun varies from month to month, you can check the actual times as well as locations of the sun and moon on www.photoephemeris.com.

Because of the movement of both the moon and the earth, you will need to use a relatively

fast shutter speed to photograph the moon, especially if you are using a long lens or want to record detail in the moon. The moon moves its own width in the sky over a period of only two minutes! With a 200mm lens you should be shooting with your shutter speed at no slower than 1/250 second. You can open up your aperture or increase your ISO in order to increase your shutter speed. There are also ways to minimize or downplay the motion that a slower shutter speed will produce. Try using a shorter focal length lens, making the moon much smaller in your composition. I've found that I can comfortably shoot a 30-second exposure of the full moon just by switching to a wide-angle lens—the moon will no longer be a crisp well-defined ball, but rather a diffuse but still-round point of light.

Silhouettes

When shooting a silhouette, it is crucial that your subject is positioned against a background that is much lighter in tonality, or it will not show up well (a cloudless dawn or dusk sky is ideal). For example, if you are photographing a back-lit fisherman standing on a jetty at sunset, get low enough so that the sky becomes the background, or high enough so that the water is the background. Choppy water is often too dark to serve as the backdrop for a silhouette, but if the water is calm it will reflect the color and tonality of the sky more easily.

Another thing to watch out for in a back-lit scene is merging silhouettes. Avoid having two overlapping fishermen, or having a fisherman's head "merge" into the distant shore, as can happen so easily at Menemsha. Rather than appearing as separate objects, the black shapes of any silhouette will run together in your photo. The spaces between your silhouetted figures (negative space) can be as important as the figures themselves. Gesture is also key—would you rather catch the fisherman at the moment

he (or she) is winding up to make a long cast or when he is just standing there with his fishing line in the water?

Reflections

I love photographing reflections, and living on an island, I have plenty of opportunities. Reflections work best when the subject (often a boat) is in the sun while the water is in shade.

Red boat, Edgartown Harbor

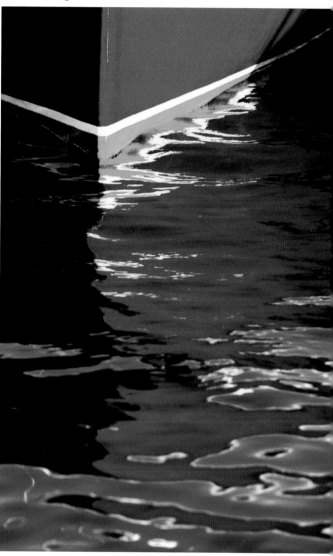

Rough water won't work, and conversely I find flat-calm water to be "too" perfect. Ideally the water should be calm, but with occasional interruptions to break up the reflection—a light puff of wind, the wake of a boat going by, or even the ripples from a stone that you've tossed in the water.

Select a shutter speed fast enough to stop the motion in the moving water, and an aperture small enough to get the subject, the surface of the water, and the reflection all in focus.

Lighthouses

Look for interesting weather with unusual lighting conditions to set the scene for your lighthouse photo, whether it's fog, white puffy clouds, dawn, or dusk. The advantage of shooting in low light is that the light in the lighthouse will actually show up—all the better if the light is red. Including that red light could be the difference between a stunning photo and a boring one. Spend a few seconds observing the light and measuring the time between flashes, so you can set your shutter speed accordingly and then time the moment you press the shutter to maximize the intensity of the light.

Both the best and the worst thing about photographing lighthouses is that they are innately picturesque and appealing subject matter. It's hard to pass by a lighthouse without stopping to take a picture, and it's not too difficult to capture a good photograph of a lighthouse.

Edgartown Lighthouse

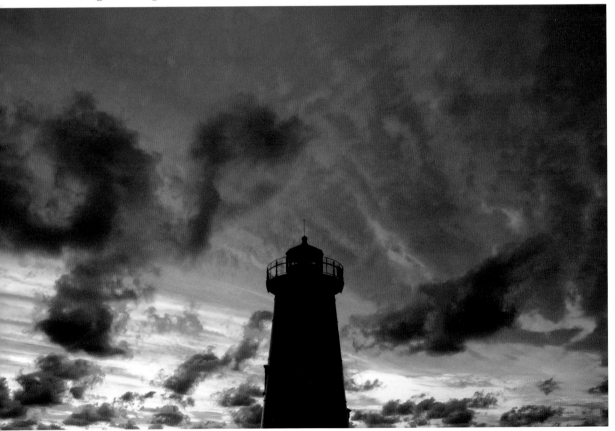

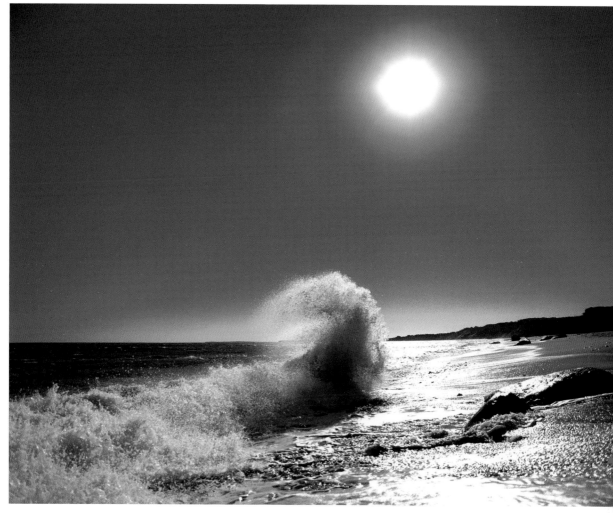

Lucy Vincent Beach

The challenge is in going beyond trite. In order to put your own mark on the photo, try shooting with a super wide-angle lens, come in close to capture a detail, shoot the lighthouse with beach grass as a foreground element, or lie down in the sand and shoot skyward.

Ocean and Rocks

I especially enjoy photographing the ocean waves as they break over the rocks, and Lucy Vincent Beach is the best place to find this subject matter. Try using a really fast shutter speed (1/500 or faster) to freeze the salt spray as it hits the rocks, or a really slow one (one second or slower) to make a soft continuous "blanket" of moving water. If you are using faster shutter speeds, put your drive on continuous high, and hold the shutter-release down as the wave approaches and hits the rocks (it's not like the film days, when this suggestion would make you cringe at the thought of "wasting" film). If you are using slower shutter speeds, have your

South Shore

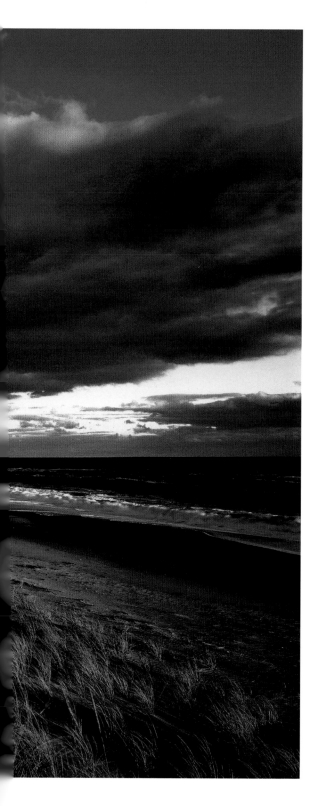

camera on a tripod. Slowing your shutter speed sufficiently to show the moving water will be easier to accomplish in the dimmer light around dawn or dusk. In brighter light, I use a few tricks to slow down my shutter speed: stop your aperture all the way down, set your ISO as low as it will go, or add a polarizing filter to slow your shutter speed down by an additional two stops.

Light, Weather, Seasons

Light and Weather

There are a handful of weather and lighting conditions that send me rushing out with my camera, regardless of what I had planned to do that day.

If I hear the words "strong cold front" from a weather forecaster, I sit up and take notice. In a cold front, warm wet air is pushed up and out of the way by colder dry air. This phenomenon is often accompanied by dramatic clouds as the sky rapidly transitions from dense overcast to crystal clear blue. If this occurs during the "magic hour" of light, then you could be in luck. One of my most successful photos was taken in these conditions. It was early October and the weather had been miserable for a week or more when I got the word about a cold front. At the first sign of a break in the cloud cover I headed for a favorite beach on the south shore. It was a race against Mother Nature that necessitated loading film into my medium-format film camera, in my lap, as I drove down a very long and bumpy dirt road. I only had a few seconds to capture the windswept scene of the beach, with a rapidly receding band of clouds overhead and the warm pre-sunset glow of the sun on the dunes.

In spring or fall, warm days and cool nights (there might be a "chance of frost" in the forecast), and calm or light winds (5 mph or less) are the perfect combo for early morning mist

hovering over sheltered bodies of water. My preferred spots to photograph the mist are at the head of Lagoon Pond near the herring run, or Farm Pond, both in Oak Bluffs.

I love flat, calm water in the early morning. Even better are those first few seconds or minutes just when the wind starts to pick up a little, sending intermittent wind-generated ripples across the otherwise glassy water. Look for boats, docks, seabirds, and their reflections, paying close attention to what the wind and water are doing. The water is most likely to be calm at dawn—typically the wind builds up during the course of the day, dropping back down again at night.

I also enjoy taking pictures when there are northerly or easterly winds, crisp blue skies, and cumulus clouds. I watch for the "young" clouds when they first form—they are much more distinct than the older more diffuse clouds, which become spread out and ragged at the edges. A polarizing filter is the perfect accessory to make the clouds more dramatic against the deep blue sky.

There's No Such Thing as "Bad" Light

The only bad light I can think of is from fluorescent bulbs—other than that, "bad" light is never a good reason to put your camera down. The trick is to match your subject matter to your lighting. I learn this lesson time and time again on photo workshops, when we photograph regardless of the conditions. We are not waiting for the "perfect" light, but rather we are working with the light we get. It's hard to go wrong when you are in the midst of a beautiful scene and the light is magical, but the reality is that those conditions are the rare exception and not the rule.

Even noontime on a hazy sunny day is no reason to pack it in—that's a time to look for a shady spot and shoot close-ups in the flat, even light. How about dusk on a rainy day? Your

photos will have an exquisite deep blue hue to them. And when it's too dark to shoot? As long as you can get a meter reading you can take a photo. Bright blue cloudless sky? Perfect as a backdrop for colorful beach umbrellas.

Bad light requires more creativity from the photographer. My work with motion and "painting" with my camera evolved in part out of pushing myself to shoot in conditions that otherwise would not have inspired me. A creative approach can transform "nothing" into "something."

Not Just a Summer Island: Photographing the Vineyard Year-round

Your experience of the island is going to be very different depending on what time of year you choose to come. My favorite season to enjoy the island without my camera is the summer, and my favorite time to photograph the island is September and October. The photographic down-sides of summer include the crowds, finding a place to park, waiting in line for just about everything, no access to private beaches, the sun rising too early and setting too late—need I say more?

It's not a coincidence that I teach my Vineyard photography workshops in the brief window from mid-September to mid-October. Autumn light and weather conditions are the most interesting. While summer is apt to have day after day of hot, hazy, humid conditions, there is nothing dull about fall, with the weather in constant flux. It also benefits the sleep-deprived photographer to have the sun rise a little later and set a little earlier. This is the time of year that we islanders are able to reclaim the island as our own, whether it is walking right into the Black Dog Tavern for breakfast without a wait or finding a parking space in Menemsha at sunset.

The only thing lacking on the island in the autumn is dramatic fall foliage. I can practically

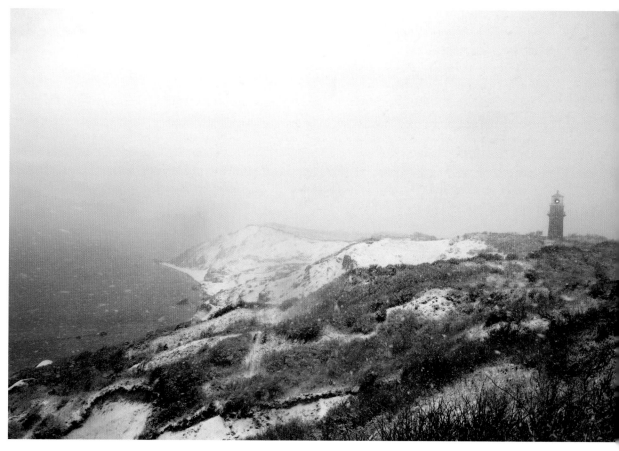

Winter snowstorm, Gay Head Cliffs

count on my fingers and toes the number of colorful maple trees on the island. The fall color palette tends more toward the soft ochre of marsh grasses, the dreary brown of oak leaves, and an occasional punctuation of vivid color.

In the winter months, I live for snowstorms and deep freezes. The rest of the time it's pretty much raw, damp, and bleak, which leaves me uninspired and inside. But when we occasionally luck out and get snow as opposed to freezing rain, I am like a school kid on a snow day. As soon as an inch or two of snow covers the ground, I cancel out of everything in my appointment book and head out in my trusty Toyota 4Runner, not to return home until nightfall. I remember one winter vacationing in Key West and reading about a particularly paralyzing snowstorm that hit Cape Cod and the Islands. At the time, I was on a rubber raft in a pool sipping a gin and tonic, 90 degrees with a cloudless blue sky overhead. Yet if I could have clicked my heels three times and been plunked down in the middle of that snowstorm with my camera, I would not have hesitated for a second.

Years ago I discovered the magic of shooting *in* a snowstorm rather than *after* a snowstorm. My photos went from being boring to having mood and atmosphere. When it's snowing, use a wide-angle lens, so snowflakes in

close proximity to your lens will look like tiny delicate specks rather than giant out-of-focus white blobs. And use a lens hood and skylight filter to protect your lens.

My favorite places to photograph in the snow are Ocean Park in Oak Bluffs, the gingerbread cottages of the Martha's Vineyard Camp Meeting Association, Menemsha Harbor, and up-island fields with cedar trees and stone walls.

Icy cold conditions can provide great conditions for photography, whether it's sea smoke on Vineyard Sound wafting near the water's surface, or the ponds and harbors icing up after a long stretch of freezing temperatures. I am constantly looking for conditions that transform the island landscape—from a visual standpoint, winter weather phenomena turn the island into a very different place.

Some years, spring doesn't arrive on the island until late May. This results from being surrounded by chilly ocean waters, having the landscape dominated by oak trees that are painfully slow to leaf out, and weather that is notoriously unpredictable. That said, we do have an abundance of spring bulbs and flowering trees. The Polly Hill Arboretum in West Tisbury is a particularly lovely location to photograph in the spring, as is Mytoi on Chappaquiddick.

Canada geese

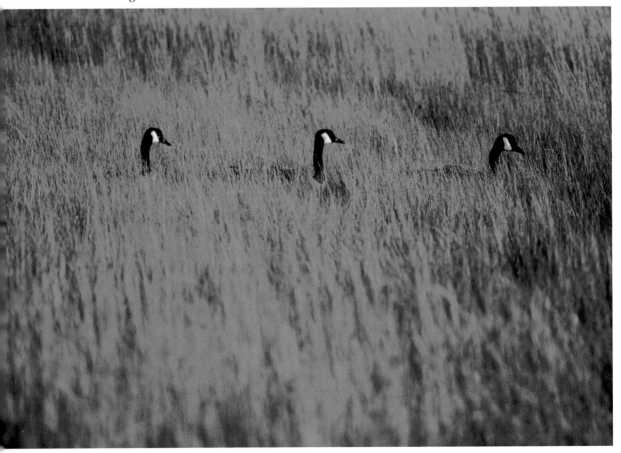

Logistics: Getting Around

People arrive on the island for the first time thinking to themselves, "It's an island, after all, how big could it possibly be? I'll just walk or rent a bike." The island is 21 miles long, the roads are extremely narrow and hilly up-island, many of the better photo locations are off the beaten track, often the best light is either very early or very late, and you've got gear to carry. Although the island has an excellent public transportation system in the Vineyard Transit Authority and a remarkable network of bike trails, the only way to *really* see the Vineyard with your camera is to do it by car. Oh, and one more thing—for safety reasons don't, under any circumstances, even *think* about renting a moped.

A word of advice when finding your way to the locations described in this book: I'd trust my directions and the accompanying maps over a GPS, which tends to get tripped up by esoteric, out-of-the-way island addresses.

In the summertime, the traffic is bad and parking is worse. I avoid Edgartown whenever possible, since it's always a challenge to find a parking place in town (you can always park on the outskirts of town and take the trolley, although when I am photographing I like to have my car and extra gear close by). And if Edgartown is challenging, then Menemsha anytime close to sunset is next to impossible—best to arrive many hours before sunset (or wait until September!).

Hazards

At the top of my list of hazards for photographers visiting the island are salt spray, sand, poison ivy, ticks, skunks, and deer.

On the south-facing beaches when the waves are breaking, there can often be salt spray in the air. In these conditions I use a skylight filter, since I'd much prefer cleaning my filter to cleaning my lens. I also wipe down all of my equipment with a damp chamois cloth once I'm done for the day.

Sand and camera gear are not a good mix. I take all possible precautions to ensure that they keep a safe distance from one another. I never put my camera bag down on the beach—instead I put it on a rock or drape it over my tripod. If there is blowing sand, I will also keep my camera bag securely closed and use a skylight filter on my lens. If I am using a tripod, I will keep the bottommost leg sections of my tripod fully extended so that no sand will get into the lowest joints.

There are a few things about Martha's Vineyard that will never make their way into any chamber-of-commerce publication. Poison ivy lines many walking trails—watch for the three shiny leaves, bright red in the fall. Ticks are just waiting to scurry off of blades of high grass and onto the legs of your pants, and tick-borne diseases can be devastating long-term. Deer ticks, the size of a sesame seed and particularly hard to see, are the most dangerous. Be alert for skunks crossing the road in front of your car, and don't be surprised if you come across one on the beach during dawn or dusk hours—just remember they are just as unhappy to see *you* as you are to see them, so you should be fine as long as you give them a wide berth.

Deer, while they can be a "plus" if you are lucky enough to find one who will pose for your camera in an up-island field, are a dangerous menace when encountered in the darkness along narrow, winding roadways. When headed home after a sunset shoot in Menemsha, I am apt to drive well under the speed limit, and always keep a vigilant watch out for deer emerging from the woods ("emerging" can more often than not translate as "leaping over a stone wall and bounding into the road at the blink of an eye"). And one more thing—where there is a single deer, there is apt to be at least one more.

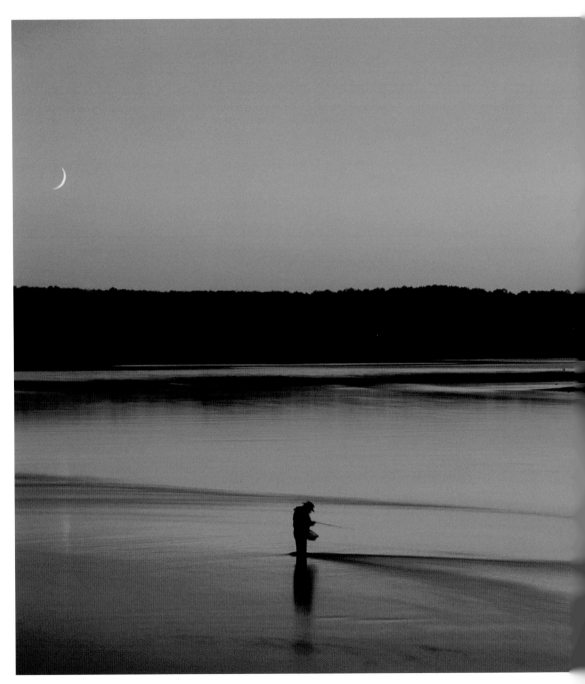

Fly fisherman, Sengekontacket Pond

I. Edgartown

Where: Eastern end of the island

Noted for: Quintessential New England coastal town, whaling captains' homes, lighthouse, white picket fences, yachts, gardens, beaches

Best Time: Summer or fall for photographs, summer for vacation

Public Restrooms: At the Visitors Center on Church Street

Sleeps and Eats: Plenty in town, seasonal and year-round

Sites Included: Edgartown Village, Edgartown Harbor, Emily Post House garden, Edgartown Lighthouse, South Beach, Farm Institute, Felix Neck Wildlife Sanctuary, Bend in the Road Beach, State Beach, Sengekontacket Pond

General Description: The first European settlement on the island was in Edgartown, then known as Great Harbor, in 1642. Edgartown's character dates back to the glory days of the whaling industry in the mid-19th century. Rich in history, the center of town has stately cedar-shingled or white clapboard homes, brick sidewalks, old-fashioned lanterns, flowers overflowing from planters and cottage gardens, white picket fences, glimpses of the picturesque harbor, high-end gift shops and restaurants, and a decidedly "yacht club" genre of attire. Edgartown is one of the wealthiest towns on the island and boasts hundreds of multimillion-dollar homes, owned mostly by summer residents.

The south shore of Edgartown owes its terrain to the retreat of the last of the great glaciers, where the sprawling, flat, grassy outwash plain borders miles of ocean beach.

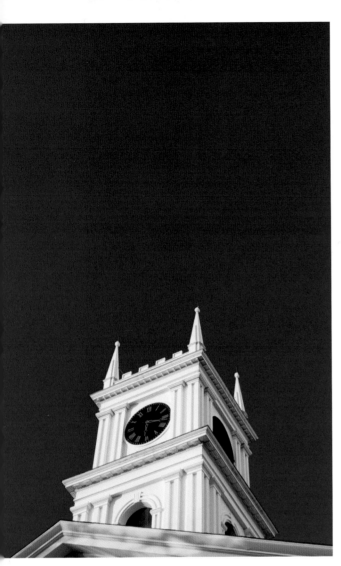

The Old Whaling Church

1. Edgartown Village and Harbor

Upon arrival in Edgartown, your first challenge is to find a parking space. Once that's accomplished, the rest is easy, since it's kind of like stepping into your own picture postcard. The town is pleasantly walkable, and you are guaranteed to find photo ops in any direction.

Main Street is more for strolling, shopping, and dining than for picture-taking, but there is one cluster of buildings that make it worth putting down your ice cream and picking up your camera. These are the Whaling Church, the Dr. Daniel Fisher House, and the Vincent House, all owned and meticulously maintained by the Martha's Vineyard Preservation Trust. The gardens are lovely, and in May the flowering apple trees make a great foreground element for a shot of the Vincent House and church.

The bell tower of the majestic Whaling Church is like a sentinel keeping watch over Main Street. After you've taken a few pictures of the lofty exterior, with its massive columns, be sure also to take a look inside. The Daniel Fisher House is unusual in its imposing size and ornamental detail. The Vincent House dates from 1672 and is the oldest house on the island. It was moved to its current location from the shores of the Edgartown Great Pond. The interior architectural elements are original and span three centuries—there are some wonderful opportunities to photograph details and textures, and the volunteer docent should be fine with your using a tripod.

Dock Street, located at the foot of Main Street, provides lots of public access to the harbor. Check out the area around the Edgartown Yacht Club and also by the Town Wharf. Opposite the Chappaquiddick Ferry landing, stop by the Old Sculpin Gallery, originally a part of Dr. Daniel Fisher's whale-oil refinery, and later a boat shed where Manuel Swartz Roberts crafted wooden catboats. On the grounds adjoining the gallery is an antique wooden lifeboat.

North Water Street is probably the most photographed street on the island, and worth walking all the way to the end. There you will find the historic Harbor View Hotel, with its sprawling porch and wooden rockers overlooking the Edgartown Lighthouse and outer harbor. Along the way you will pass homes

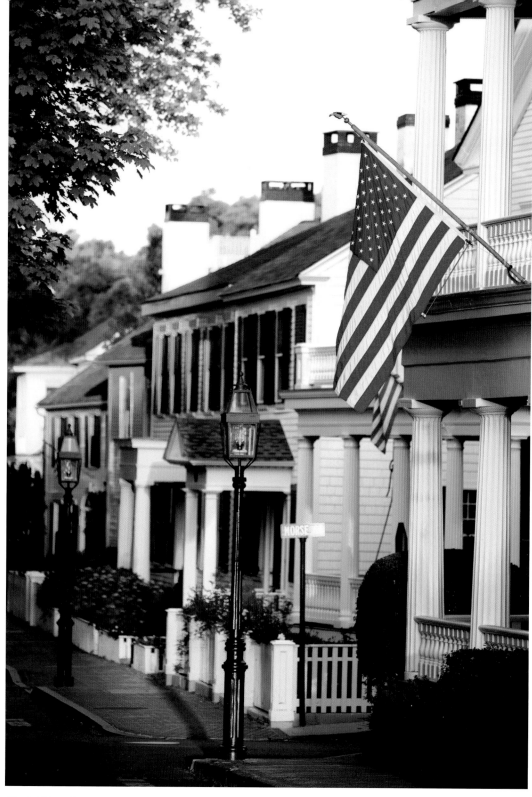

North Water Street

built in the mid-1800s for the captains of whale ships (at least one of the houses still has its widow's walk). If you come at dawn, the old-fashioned street lamps will be aglow until close to sunrise. For several weeks in early June, the first rays of sunrise align perfectly with North Water Street, lighting up everything in their path with an orange glow. Be sure to work fast, since you'll only have a few minutes to capture the magic.

South Water Street is similar to North Water Street (minus the lighthouse). In front of the Harborside Inn you'll see a towering pagoda tree brought back from China in a flowerpot by a whaling captain almost 200 years ago, and said to be the oldest tree of its kind in North America.

2. Emily Post House Garden

The prettiest little cottage garden in town is at the house formerly owned by Emily Post, America's foremost authority on etiquette. Although the house is no longer in the Post family, the gardens are still tended by the Post family gardener, who each fall lovingly digs up the dahlia bulbs and then replants them each spring. While the garden is small in size and on private property, it is situated so as to be enjoyed by all who pass by. The best time to photograph it is very early morning in late August or early September, when the dew-laden dahlias are in full splendor.

Directions: If you head north on Fuller Street, the house will be on your left shortly after the intersection of Cottage Street.

3. Edgartown Lighthouse

This is the most photogenic lighthouse on the island, in my opinion, due to its setting and an abundance of additional subject matter. Dawn and sunrise are my pick for time of day, although the lighthouse is in such a wide-open,

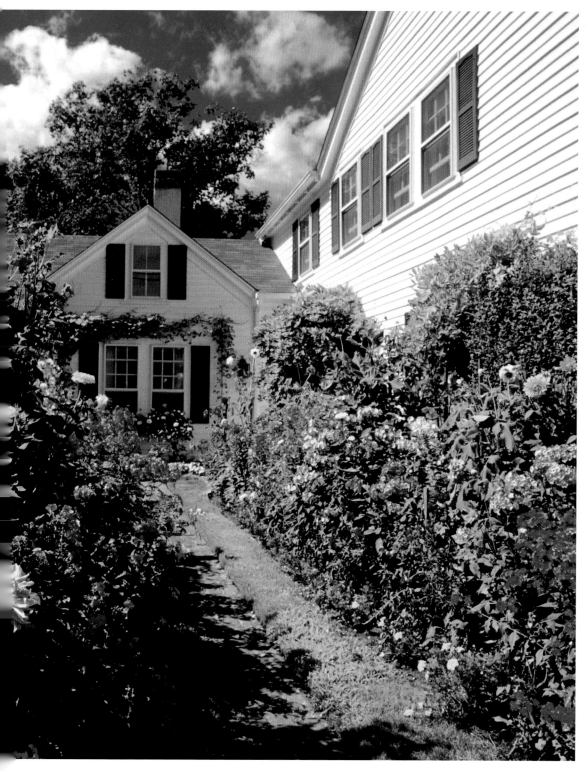

The Emily Post House

picturesque location that it's photogenic almost any time of day. If you choose to go for early morning, try to arrive when it's still dark, and don't forget your tripod and a flashlight. At the bottom of the footpath, first make a stop on the near side of Eel Pond. Position yourself so that you can see the lighthouse in the distance across the pond—the water is often still at this time of day, and it's a perfect spot to shoot the reflection of the lighthouse and grasses in the pond. Time your photo so you capture the lighthouse's red light.

As daylight approaches, take a few minutes to absorb the rest of the scene—cedar trees, marshland, boats bobbing at their moorings, herring gulls overhead, and a view of Chappaquiddick across the outer harbor. In early fall you'll likely glimpse a profusion of goldenrod, fly fishermen on the sandy point casting for bonito and bluefish, and if you're lucky some migrating monarch butterflies stopping for a respite on their journey southward.

Directions: From Main Street in Edgartown turn left onto North Water Street. Go 0.6 mile; you will see the view of the lighthouse on your right. Park in front of the Harbor View Hotel, and follow the path directly opposite down to the lighthouse.

Edgartown Lighthouse

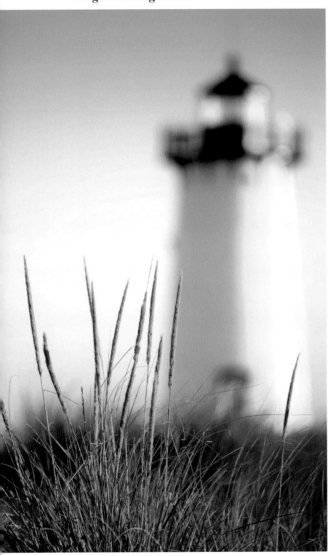

4. South Beach

While South Beach is not the Vineyard's most interesting beach, it is its largest and most accessible public ocean beach. Photographers should keep in mind the time of day and weather conditions—noon on a sunny summer day is pretty much out of the question, unless you want to drive around for an hour competing for a parking space and then photograph a tightly packed tapestry of sun-worshippers. Try early morning, late afternoon, in the fog, or just as a September cold front moves through.

Shoot with a slow shutter speed to show motion in the water, or with a fast shutter speed to freeze a breaking wave. Use a wide-angle lens to get a big sweeping view or a telephoto to isolate your subject matter. Big waves make for dramatic photos—you can check out the status of the surf at South Beach online from the comfort of your hotel room via the Martha's Vineyard Coastal Observatory webcam: http://mvcodata.whoi.edu/cgi-bin/mvco/mvco.cgi.

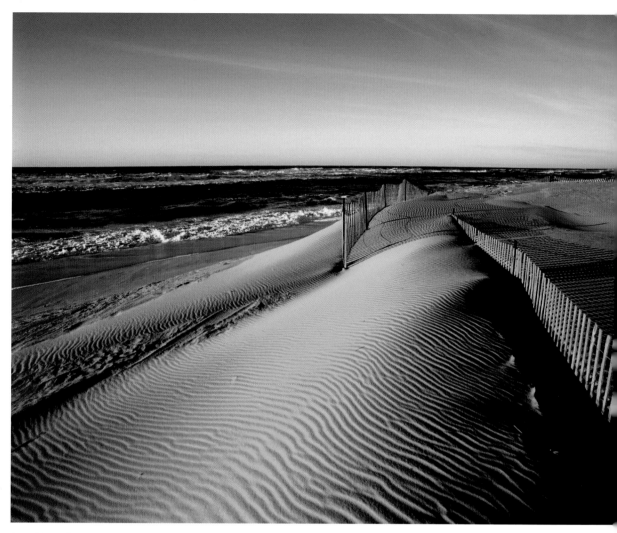

South Beach

Directions: Take Pease's Point Way from Edgartown center, following signs for Katama. South Beach is about 3 miles from town. Once you reach the beach, look for a parking space. From this point, the public beach extends both eastward and westward. If you turn right onto Atlantic Avenue, you'll find lots of additional parking and beach access.

5. Farm Institute

The Farm Institute at Katama Farm (www .farminstitute.org) is a nonprofit teaching farm open to the public. There are plenty of subjects to keep a photographer busy. Their cast of farm animals includes Belted Galloways, otherwise known as "Oreo cookie cows." Depending on what time of year you visit, you might see and photograph early morning mist over a newly plowed field, planting, lambing, sheep shear-

ing, harvesting, the farm stand, newborn calves, haying, herbs drying, piglets, chickens and eggs, the children's garden, or a steady stream of Canada Geese flying overhead in the autumn. The farm is pretty gritty, low-key, and "real," and they don't mind having photographers wandering around.

Directions: Take Pease's Point Way from Edgartown center, following signs for Katama. The turnoff for the Farm Institute will be 2 miles from the intersection of Pease's Point Way and Cooke Street. Turn right onto Aero Road, where you'll also see a sign directing you to the farm.

6. Felix Neck Wildlife Sanctuary

The 350-acre Felix Neck Wildlife Sanctuary, located on the western shore of Sengekontacket Pond, has 4 miles of well-maintained hiking trails through fields, marshland, woods, beach, and among reptile and waterfowl ponds.

Birders consider Felix Neck to be prime ground for viewing and photographing more than 100 species of native birds, including a

Black crowned night heron, Felix Neck

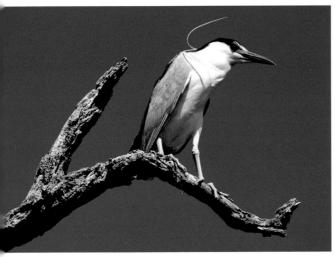

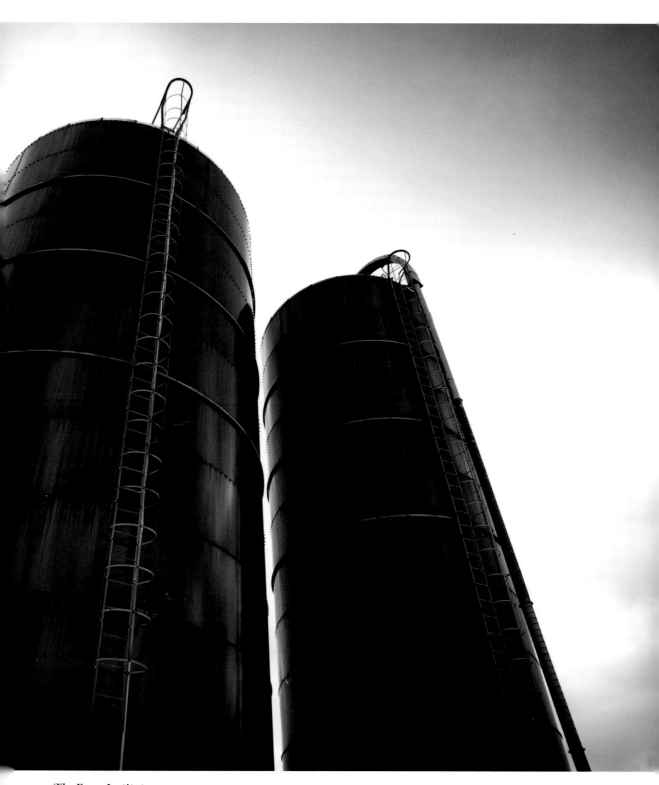

The Farm Institute

Beach Roses, State Beach

Yellow boat, Bend in the Road Beach

pair of nesting ospreys who are summer residents of the sanctuary. I especially enjoy watching and photographing avian visitors at the waterfowl pond from the observation building and deck.

You can participate in monthly full-moon meanders by kayak in the summer months and on foot in the off-season. Photograph the moonrise over Sengekontacket Pond—take in the broad scene and use a fast enough shutter speed so that the moon doesn't blur.

Directions: Follow the Edgartown–Vineyard Haven Road from the Edgartown Triangle area for approximately 2.0 miles. On the right you will see a Mass Audubon sign at Felix Neck Drive. Turn right onto Felix Neck Drive, travel 0.7 mile to the parking lot, and follow the path to the nature center.

7. Bend in the Road Beach
8. State Beach
9. Sengekontacket Pond

One of the most scenic stretches of road on the entire island is Beach Road between Edgartown and Oak Bluffs, with water views in every direction. If you look east, you can photograph the sun rising over Nantucket Sound. If you look west, you can photograph the sun setting over Sengekontacket Pond. No big waves here (unless you go in the middle of a nor'easter), since the beach faces the relatively sheltered sound.

Bend in the Road Beach is a good starting point, with plenty of parking and a crescent-shaped beach with easy access.

Toward the Edgartown end of Beach Road,

Morning Glory Farm

and-white photo over 30 years ago of three kids jumping from the bridge, and it is still one of my most-requested prints. In the autumn the bridge and jetties attract photogenic fishermen competing in the fishing derby, and anytime the easterly winds gust to 25 mph and up, you'll find some of the most expert kite boarders and wind surfers in the country gathered in this area, performing phenomenal feats of athleticism.

Directions: On the outskirts of Edgartown, at the juncture of the Edgartown–Vineyard Haven Road, stay to the right on the main road. The parking lot for Bend in the Road Beach is 1.0 mile on your right. There is also roadside parking for the entire length of Beach Road that fronts State Beach.

Non-photographic Diversions

You'll find the **Town Wharf** at the end of Dock Street. Take a seat on the dock and watch fishermen jig for squid and kids fish for scup with their drop-lines. Or better yet, climb up top, find a vacant spot on the long wooden bench, and sit back and enjoy one of the prettiest views on the island, including the comings and goings of the Chappy Ferry and the many sailboats tacking back and forth through the perilous current at the entrance to Edgartown Harbor.

The **Martha's Vineyard Museum** (www .mvmuseum.org) is a treasure trove of island history, with plenty of fascinating exhibits that are always changing and always worthwhile. Of special note is the Fresnel lens located in a brick lighthouse tower on the museum grounds. This lens was designed and manufactured in France in 1854 and consists of over 1,000 individual prisms. It was exhibited in the Paris Exposition of Industry in 1855 and was subsequently installed in the Gay Head Lighthouse, where it served as a beacon to boaters for the next 100 years before being removed by the Coast Guard and relocated to the museum's

I love the views across the marsh to Sengekontacket Pond. The color of the marsh grass changes during the year, but I most enjoy the lush green of early summer and the burnt sienna of late October. Add a great blue heron and you should walk away with a great photo.

The Edgartown Bridge on State Beach, situated at the Edgartown–Oak Bluffs town line, is best known for the summertime ritual of kids jumping into the waters below. I took a black-

campus. It is lit nightly, in case you'd like to go back after-hours for a photo.

Morning Glory Farm (www.morningglory farm.com) is the island's largest and most beloved farm stand. It is owned and run by two generations of the Athearn family. The farm is famous for its sweet corn and field-ripened tomatoes, and its kitchen produces zucchini bread and peach pie (my favorites), among other irresistible delicacies. In the summer, look for bouquets of flowers in tin cans on the porch. The exterior of the farm stand really comes to life in the fall, with a profusion of mums, pumpkins, cornstalks, gourds, and fallen leaves everywhere you look—a quintessential New England autumn scene. I was fortunate to photograph a book about the farm,

Morning Glory Farm and the Family That Feeds an Island, published in 2009 by Vineyard Stories.

Katama Airfield (www.biplanemv.com) is an all-grass airstrip located near South Beach. The airfield is home to two sightseeing biplanes, one red and the other white, as well as to a handful of rare species of plant life. Viewing the island from above via biplane is a heck of a lot of fun (you kind of feel like the Red Baron . . .) and can also produce some great photos.

The airstrip is also home to the **Right Fork Diner** (www.rightforkdiner.com), where you'll find the best blueberry pancakes on the island. And you can enjoy your breakfast or lunch on their deck, watching the planes come and go.

Red biplane over Katama

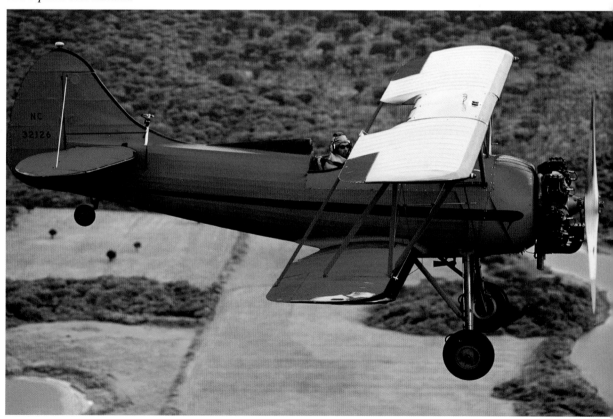

Mytoi

II. Chappaquiddick

General Description: The fact that Chappaquiddick (or "Chappy" to the locals) is an island off an island (requires two ferry rides if you're coming from "America") gives you a pretty good idea of what the island and its residents are like. It's isolated and hard to reach ($12 for a car and driver and often an hour-long wait for the ferry in-season), has a single speed limit of 25 mph, and offers virtually no services or conveniences. Its small but hardy band of year-round residents wouldn't have it any other way.

Technically speaking, Chappaquiddick is sometimes an island and sometimes not. It used to be joined with Edgartown along the south shore, passable only by over-sand vehicles. A breach in the barrier beach occurred during a spring storm in 2007, and there's no sign of its closing up again in the near future—assuring Chappy's status as an island, at least for the time being.

Chappaquiddick is a largely undeveloped, unspoiled tract of scrub oak and marsh grass, with some of the most beautiful and pristine beaches, ponds, and vistas on the Vineyard. It's also a favored destination for shore fisherman.

10. Mytoi

Mytoi is a Japanese-style garden owned and managed by The Trustees of Reservations. The word "Mytoi" has no translation in Japanese—Hugh Jones, who originally created Mytoi, spent so much time in his garden that he referred to it as his "toy."

In 1991, Hurricane Bob and some accompanying mini-tornados left the garden a tangle of uprooted trees and shrubs. It was entirely redesigned and replanted as a place of quiet

Where: An island that is part of Edgartown, at the far eastern end of the Vineyard

Noted for: Ocean beaches, conservation land, largely undeveloped, Dike Bridge and the Kennedy tragedy, surf fishing, Japanese garden

Best Time: Fall for photographs, summer for vacation

Public Restrooms: At Wasque and Mytoi

Sleeps and Eats: No sleeps. The Chappy Store is open in-season only.

Sites Included: Mytoi, Cape Poge Wildlife Refuge, East Beach, Poucha Pond, Quammox Preserve, Wasque Reservation

contemplation, with vegetation that is a combination of exotic and native species. Its centerpiece is a tranquil pond, with an island reached via an arched footbridge. Winding footpaths take visitors through a birch walk, camellia dell, stone garden, hillside garden, and by trickling streams.

The serenity of the garden inspires photographers to slow down and appreciate its intimate vignettes. There are also lots of opportunities for macro photos.

Directions: From the Chappy Ferry, travel 2.4 miles. At a sharp right curve, go straight onto Dike Road. Mytoi will be on your left.

11. Cape Poge Wildlife Refuge
12. East Beach
13. Poucha Pond

Chappaquiddick Island's eastern edge is a barrier beach formed thousands of years ago by offshore currents that deposited tons of sand.

Today this beach extends for 7 miles from Wasque Point on the south past the Cape Poge Lighthouse to Cape Poge Gut. East Beach is a long, beautiful, and relatively empty stretch of beach, managed by The Trustees of Reservations, and with lots of great subject matter for photographers.

West of the dunes lies Cape Poge Bay, where clear, sheltered waters provide some of the best bay scalloping on the Vineyard. The Cedars, stretching between bay and ocean, is a grove of century-old, low-growing eastern red cedars sculpted by salt spray and wind.

At the northernmost tip of the sand barrier stands the shingled and still operational Cape Poge Lighthouse, the latest incarnation of which was built in 1893. It's an over-sand trek of more than 3 miles out to the lighthouse, so I'd suggest taking one of the Trustees' natural history or lighthouse tours (visit www.the trustees.org for schedule and prices). This area, with its outermost lighthouse, is about as remote and unspoiled an area as you'll find anywhere on the Vineyard.

Poucha Pond is a small, sheltered pond, ideal for exploring by kayak. The Trustees make that easy by providing rental kayaks and a self-guided discovery tour of the pond.

The only frustration for photographers visiting this area is that, although most photogenic at sunrise, it is also inaccessible at sunrise for much of the year, since the first trip of the Chappy Ferry isn't until 6:45 AM. With advance notice, and for an extra $20 you can schedule a 6 AM trip. (See www.chappyferry .net for a complete schedule.)

Directions: From the Chappy Ferry, travel 2.4 miles. At a sharp right curve, go straight onto Dike Road. The road ends in a parking lot at Dike Bridge (if you want to go farther in your own car, you will need a 4WD vehicle and a

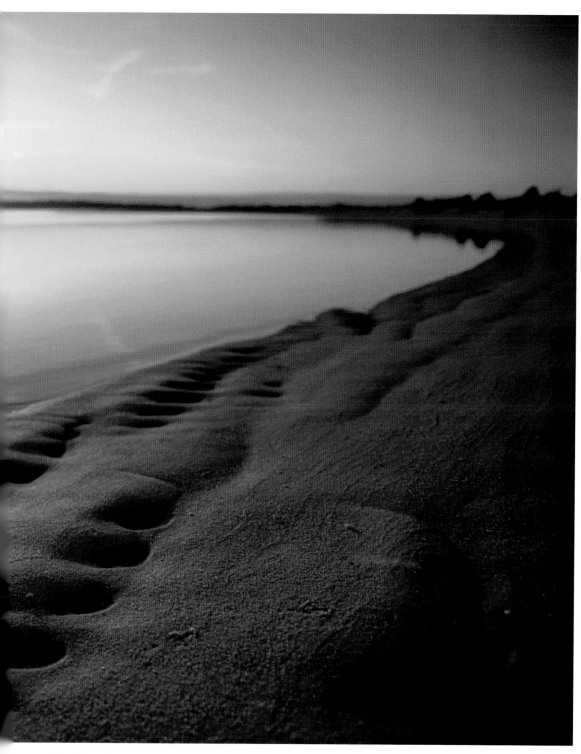

Cape Poge Bay

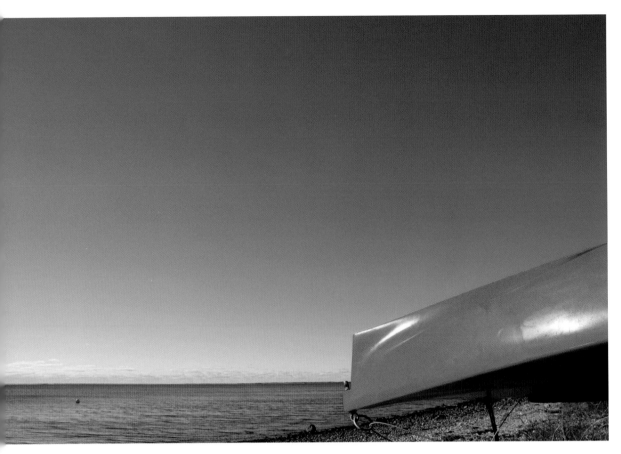

Quammox Preserve

Trustees beach sticker). Cape Poge is to your left, Poucha Pond is on your right, and East Beach is straight ahead.

14. Quammox Preserve

Quammox Preserve is a recently acquired Land Bank property overlooking Katama Bay. When you depart the trailhead, you are greeted by a sweeping view of grassland leading gently down an incline to a small pond and the bay beyond. The path leads to a rocky beach, with a view across to Norton Point Beach. There is a platform where you can store your kayak or rowboat—all you have to do is register with the Land Bank.

Directions: From the Chappy Ferry travel 3.0 miles to "Chappy 5-Corners" and turn onto Quammox Road. Proceed 0.15 mile to the trailhead.

15. Wasque Reservation

Wasque ("way-squee") is a 200-acre Trustees of Reservations property at the southeastern tip of the Vineyard. It boasts upland woods, coastal heath, protected bays, barrier beaches, and rare species of both animals and plants. It is especially popular with birdwatchers as well as with saltwater anglers.

This area has been ravaged by erosion during recent coastal storms, losing acres of pris-

tine sandy beach. It was once named by *Travel & Leisure* as the number-one beach in New England. Even though it has most likely lost that distinction, it is still a gorgeous stretch of unspoiled beach.

Walk a little way down the beach to your right and you'll come to the "cut," formed when the breach occurred in Norton Point Beach, which formerly connected Chappaquiddick to Edgartown. You'll find a swirling current and choppy conditions as you look west across the cut—good for photos but far too dangerous for swimming.

Directions: The entrance is 4.1 miles from the Chappy Ferry.

East Beach

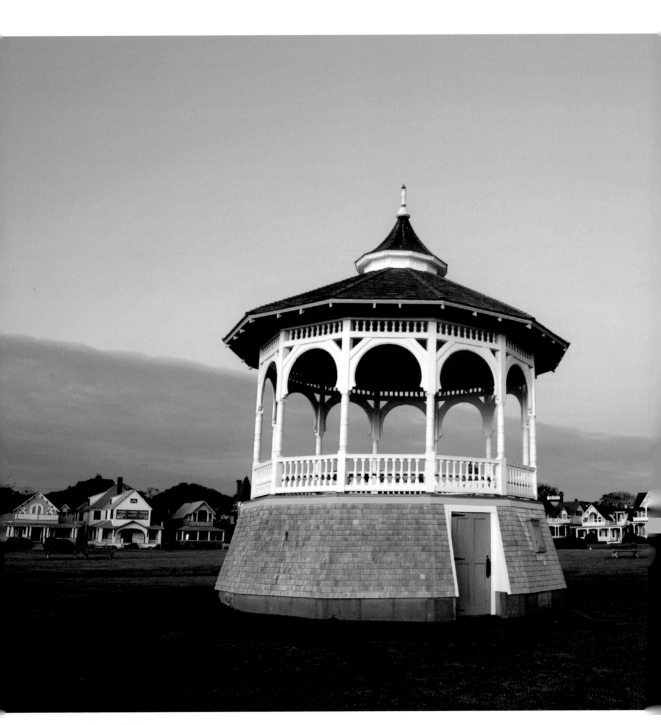

Ocean Park

III. Oak Bluffs

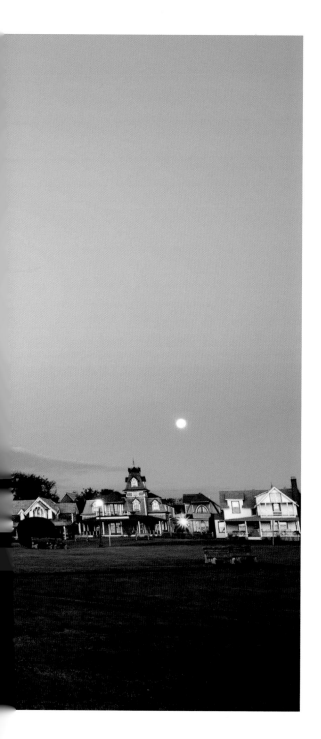

Where: On the north side of the island, bordered on the west by Vineyard Haven and on the east by Edgartown

Noted for: Victorian architecture, gingerbread cottages, seaside park with a bandstand, historic carousel, public beaches

Best Time: Summer or fall for photographs, summer for vacation

Public Restrooms: Near the Steamship Authority, near Our Market on the harbor, and near the post office on Kennebec Avenue

Sleeps and Eats: Plenty in town, seasonal and year-round

Sites Included: Martha's Vineyard Camp Meeting Association gingerbread houses, Ocean Park, East Chop Lighthouse, Oak Bluffs town beaches, Harthaven Harbor, Pecoy Point Preserve, Head of the Lagoon Pond, Island Alpaca

General Description: Oak Bluffs was the original summer resort on the island, a tradition still going strong 150 years later. It's a classic beach town, with band concerts by the sea, seafood shacks, saltwater taffy, a carousel, a couple of movie theaters, restaurants and bars overlooking the bustling harbor, all the ice cream you can eat, souvenir shops, plenty of porch rockers to while away the time, a brewery, and a seaside park perfect for kite flying.

The architecture is Victorian, whether the larger more formal houses overlooking Ocean Park, or the brightly painted diminutive Carpenter Gothic cottages of the campgrounds.

There's always been a peculiar juxtaposition in Oak Bluffs, with the Methodist Camp Meeting Association cottages, tabernacle, and revival meetings in years gone by, existing side-by-side with the lively bar and nightlife scene

Pink House, campgrounds

on Circuit Avenue (sometimes called "Sin City" by the 19th-century Methodists).

Oak Bluffs also boasts miles and miles of public beaches and bike baths, and Farm Neck Golf Course with its breathtaking 18 holes bordering Sengekontacket Pond.

16. Martha's Vineyard Camp Meeting Association Gingerbread Houses

The number–one photo op in Oak Bluffs is the gingerbread cottages in the campgrounds.

They originate from the 19th-century phenomenon of evangelical religion that swept the country and found a particularly receptive home here. The first Methodist revival meeting was held in 1835, with a modest circle of nine tents for the attendees. By 1858, 12,000 people attended the Sunday services, and thousands of them either stayed in cramped community tents or brought their own tents. Wooden platforms were built for the family tents, which soon gave way to tiny wooden cottages—spare on the inside but highly decorative and colorful on the outside. At one time there were about 500 of these cottages, just over 300 of which remain today. The big canvas revival tent in the middle of Wesleyan Grove was replaced by the present open-air wrought-iron Tabernacle in 1879.

The gingerbread cottages circle Trinity Circle and radiate out from there. It is impossible to approach the intricate network of narrow lanes methodically, so come prepared to wander a bit aimlessly and spend at least a morning or afternoon. Only some of your wandering time will be spent actually taking pictures—you'll need to leave time for some socializing, since residents who choose to live just inches from their neighbors are by definition very sociable folk. If you're lucky you might even get invited up on a porch for a lemonade or to take a peek inside a cottage.

The gingerbread cottages can be difficult to photograph. There is almost too much of a good thing—architectural details, gardens, rocking chairs, hanging planters, flags, wicker, cute kids, grandparents, tricycles, and hopscotch. . . . The trick here is to use a long lens with a shallow depth of field. One bonus to the shallow depth of field is it gives much of your image a softness that corresponds to the lazy summer mood that permeates the place. This is a small, close-knit, relaxed, old-fashioned summer community that time forgot. The

more you can conjure up that state of mind, the better your photos will be. One last thing—in order to truly enjoy and appreciate the campgrounds, it's important to plan your visit for July or August (See www.mvcma.org).

Directions: The campgrounds encompass 34 acres bordered on the east by Circuit Avenue, on the north by Lake Avenue, and by the west on Dukes County Avenue. There is ample parking within the campground property during the off-season, but in-season that parking is reserved for residents. Best to park anywhere on the perimeter, and find your way in by any one of a number of small roads or paths.

17. Ocean Park

Ocean Park is like a scene out of a Currier & Ives print—quintessential summer in an idyllic seaside setting. The recently restored bandstand provides the focal point of the perfectly maintained park, with its flowerbeds, wading pool, benches, and footpaths, bordered on one side by a sweeping view of the sound and on the other by stately Victorian summer homes. In season, Ocean Park is the location for biweekly Sunday evening band concerts by the Vineyard Haven Band, and a spectacular late-August fireworks display.

The ambience is so picture-perfect that all you need is beautiful light and a wide-angle lens. If you'd like to do something a little more creative, come at sunrise or sunset and silhouette the bandstand against the rising or setting sun. Try including the sun in your photo—use a wide-angle lens at a small aperture and position the sun so that it is peeking out from behind the bandstand. In the resulting photo you'll see a wonderful sun-star effect.

Directions: Ocean Park is near the center of town, bordered by Seaview Avenue on the east and Ocean Avenue on the west.

18. East Chop Lighthouse

The East Chop Lighthouse stands sentinel on Telegraph Hill, looking out over the headland at East Chop. A signal tower was erected here in the early 1800s as part of a semaphore system—messages were sent up and down the coast via a system of raising and lowering flags. The present lighthouse, erected in 1878, is a carbon copy of the Edgartown Lighthouse.

East Chop Lighthouse

Happily for photographers, overhead power lines were removed in the course of a recent restoration. A white picket fence makes for a nice foreground element. While there are views out over Vineyard Sound from the town park surrounding the lighthouse, they are frequently interrupted by a jumble of vegetation that makes it nearly impossible to get a clean shot of the lighthouse, sky, sea, and distant sailboats.

Directions: Leaving town and heading toward Vineyard Haven on New York Avenue, turn right at the far side of the harbor onto East Chop Drive. Follow the road up and around the bluff—the lighthouse will be 1.0 mile on your right.

19. Oak Bluffs Town Beaches

A series of town-owned public beaches stretch from the Oak Bluffs Harbor to Farm Pond. While certainly not dramatic, they offer plenty of subject matter—stone jetties, the steamship wharf, lifeguard stands, and remnants of old wooden groins and breakwaters. Go at dawn, and either shoot from the sidewalk above or walk down on the beach via one of the numerous access points. The shoreline directly faces the rising sun.

Directions: These beaches are accessible from Seaview Avenue, which extends from the harbor to Farm Pond.

20. Harthaven Harbor

Privately owned Harthaven Harbor is a delightful and picturesque little gem of a harbor, easy to photograph from the road's edge. The portion visible from Beach Road has a couple of docks, a handful of traditional watercraft, and a narrow channel leading out to the sound. It's a sheltered spot, frequently flat calm early in the morning.

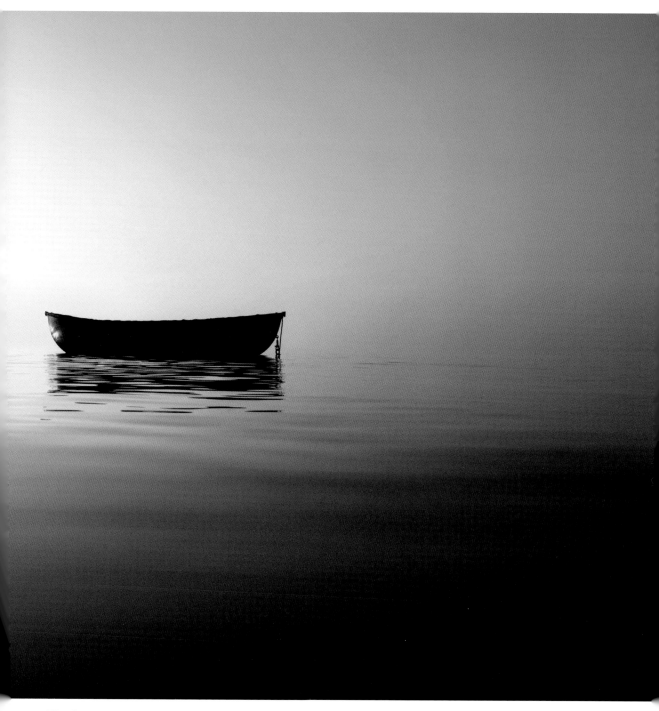

Harthaven

Pecoy Point Preserve

Directions: From Ocean Park go 1.1 miles on Seaview Avenue/Beach Road. Harthaven Harbor will be on your left and easily visible from the road. Park in the big parking lot at Lola's Restaurant/Island Inn, just beyond the harbor on your right.

21. Pecoy Point Preserve

This Land Bank property may be tiny with just a single trail, but it's a microcosm of island habitats well worth the visit. It's a unique pocket of preserved land in an otherwise residential area. There are terrific views from the shoreline across Sengekontacket Pond to Felix Neck and State Beach. The meadows are particularly stunning in October, when the mix of vegetation, textures, fall color, rusty old farm implements, and lichen-covered rocks create a rich pastoral tapestry. And don't be surprised if a couple of white-tailed deer make an appearance.

Directions: Begin where County Road meets the Edgartown–Vineyard Haven Road. Go 0.9 mile on County Road and turn right onto Pulpit Rock Road. Two dirt roads are located on the right 0.3 mile down this road—turn into the second road, which is marked by a Land Bank sign. The trailhead is located at the end of this road.

22. Head of the Lagoon Pond

This is my "go to" spot for early morning mist, spring and fall, when the days are warm, the nights are chilly, and the winds are light. With the headlands on either side, the mist has a perfect spot to nestle in and blanket the waters of the pond until the first rays of sun rapidly burn it off.

Following the short dirt causeway on foot, be sure to photograph as you go. You might see dozens of dew-laden spider webs, colorful berries and leaves in the fall, a view of the old waterworks building to your left, and often swans, geese, or osprey. A hundred yards down the narrow road, veer to your right, through the marshy area, and onto the rocky beach. The mist will turn anything in sight—grasses, boats, rocks, ducks—into an evocative photo. If the conditions are right, I promise this will be a special spot, which you'll have all to yourself.

Directions: From the blinker and four-way stop on the Edgartown–Vineyard Haven Road, take Barnes Road toward Oak Bluffs for 0.6 mile. Pull into a tiny parking area on your left, being sure not to block driveways or access roads. Immediately in front of you, you'll see a narrow dirt causeway with views of the pond on both sides.

23. Island Alpaca

For a change of pace and a guaranteed smile, plan a side-trip to the Island Alpaca Company's 19-acre farm (www.islandalpaca.com). For a modest donation, you can see and photograph these happy, friendly, humming, well-manicured creatures. There are over 50 alpacas in the current herd, all within easy viewing range. Alpacas were first introduced to this country

Head of the Lagoon Pond

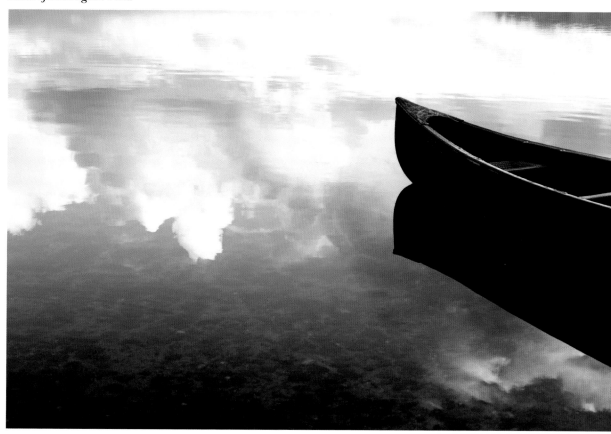

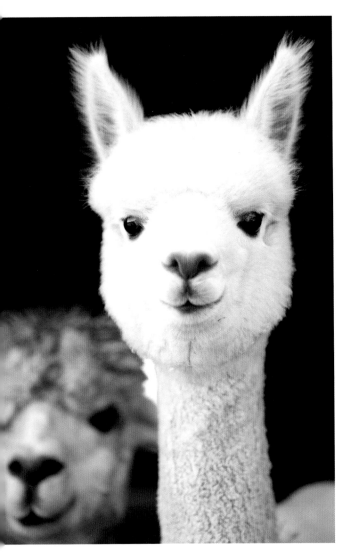

Island Alpaca

in 1984 from Peru, Bolivia, and Chile, and are prized for their luxurious fleece. While you're there, pick up a pair of fingerless gloves in their farm store—they are incredibly soft (alpaca fleece was called the "fiber of the gods" by Incan royalty) and are an essential part of my off-season photographic attire.

Directions: From the blinking light at the four-way stop on the Edgartown–Vineyard Haven Road, travel 0.2 mile toward Vineyard Haven. Take a left onto Head of the Pond Road. Take an immediate left onto Alpaca Avenue. Park and follow the signs to the barn.

Non-photographic Diversions

The Flying Horses, owned and operated by the Martha's Vineyard Preservation Trust (www.mvpreservation.org), is the oldest operating platform carousel in the country. It was built in 1876 and moved from Coney Island to the Vineyard in 1884. For a mere $2 both the young and the young at heart can have a ride and take their chance at grabbing the brass ring, entitling the lucky recipient to a free ride. When I was a summer kid on the island, the Flying Horses was our favorite rainy-day destination.

The most coveted after-hours dessert in Oak Bluffs is at the Martha's Vineyard Gourmet Café and Bakery's **Back Door Donuts** (www.mvbakery.com). On summer evenings, follow the scent of fresh-baked donuts around to the parking lot behind the bakery. I go right for the warm apple fritter, big enough to feed my entire family.

The **Alison Shaw Gallery** (www.alisonshaw.com) is located in the heart of the **Arts District**, a lively community of galleries, artisans, and specialty shops. Stop by the gallery and meet my partner and gallery co-owner Sue Dawson, who will likely be sitting at the front desk. We have fine art prints, posters, note cards, and signed copies of my latest books. I'm generally working upstairs in the studio and am always happy to come downstairs to answer questions, sign your copy of *Photographing Martha's Vineyard,* or give you a brief tour of my workspace. If you're on the island mid-July or mid-August, watch for the monthly Arts District Strolls, when all of the art-related businesses in the neighborhood put on one heck of a party.

At the Flying Horses

Alabama *and* Shenandoah, *Vineyard Haven Harbor*

IV. Vineyard Haven (Tisbury)

Where: Down-island, on the north side of the island, bordered on the west by West Tisbury and on the east by Oak Bluffs

Noted for: Working harbor, ferries, wooden boats and boatbuilding, year-round town

Best Time: Fall for photographs, summer for vacation

Public Restrooms: In the Stop & Shop parking lot and at the Steamship Authority terminal

Sleeps and Eats: Plenty in town, seasonal and year-round

Sites Included: Vineyard Haven Harbor, Owen Park Beach, William Street Historic District, Lagoon Pond Park

General Description: Vineyard Haven (also called Tisbury—technically Vineyard Haven is the post office address and name of the village, whereas Tisbury is the official name of the town) is known as the most "year-round" of Vineyard towns. In fact there's barely a storefront on Main Street that shutters its doors and windows in the off-season. It's also the year-round point of entry for ferries coming to and from the island, most notably the vessels of the Steamship Authority. The harbor area has a genuine working waterfront feel, with boatyards, marinas, boatbuilding operations, and various marine-related businesses.

24. Vineyard Haven Harbor

Photographically speaking, the harbor area is chock-full of all kinds of great subject matter. Vineyard Haven Harbor is a mecca for wooden boats and boat builders. The Black Dog Tall Ships schooners *Shenandoah* and *Alabama* are moored near the Steamship Wharf.

The stretch of beach in front of the Black

Lofting at the Gannon and Benjamin Marine Railway

Dog Tavern and adjacent to the Steamship Wharf has lots to offer the photographer who rises early. From the beach, shoot the 6 AM ferry as it pulls out of its slip, or one of the two Cornish pilot gigs moored just off the beach. If you're lucky, you might be there on one of the mornings when a crew of hardy rowers arrives early to take one of the gigs on a spin around the harbor.

At the head of the harbor and just a few steps down the beach to your right from the Black Dog Tavern, you'll find the Gannon and Benjamin Marine Railway, which has been repairing and building wooden boats for the past 30 years—the harbor is full of gorgeous wooden boats, which are a testament to their craftsmanship. You'll see a handful of classic wooden rowboats pulled up on the beach, but then walk a little farther and around to the far side of the boatbuilding shed. While three sides of the building are enclosed, the eastern side of the building is left wide open in all but the coldest winter months, when they enclose it with plastic for warmth and shelter from the elements. You'll generally find at least one wooden boat in some stage of construction, and the shed's walls are lined with nautical and boatbuilding paraphernalia. At sunrise on a day with a cloud-

less horizon, the interior of the shed comes to life with a deep orange glow as the first rays find their way into the highest rafters and deepest corners of the shed. My book *Schooner* (Vineyard Stories, 2010) chronicles the building of a 60-foot boat by Gannon and Benjamin.

If you are as tempted as I am by the smell of bacon frying, you've "earned" breakfast at the Black Dog Tavern after an early morning of photographing.

Directions: From Five Corners take the short street that dead-ends at the harbor (Beach Street Extension, but there's no street sign). Park opposite the Black Dog Tavern.

25. Owen Park Beach

Owen Park is named for gramophone innovator William Barry Owen, whose wife gave the parcel of land to the town for public use. This is a great little location along the harbor, with a

View of the Steamship Authority ferry from Owen Park Beach

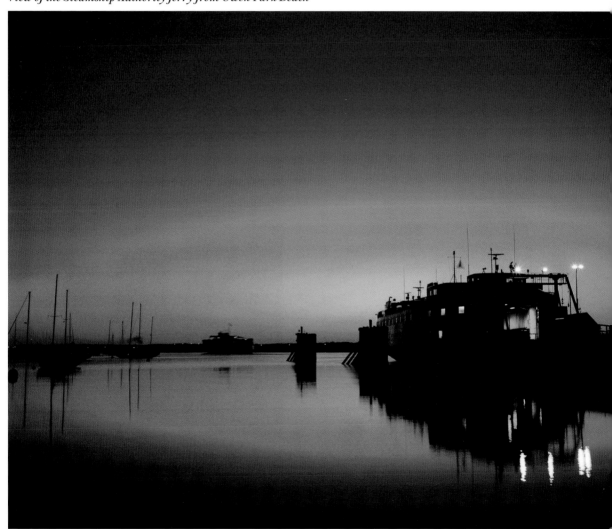

whole lot of subject matter packed into a very small area.

Early morning is best, since the view across the harbor is toward the dawn sky, and also because it is a sheltered part of the harbor and apt to be nearly flat calm at that time of day. There is ample opportunity to shoot reflections of the rowboats tied up at the town landing and the

Tisbury Town Hall, William Street Historic District

sailboats moored inside the breakwater. If you choose to photograph the back-lit boats in the harbor, use either an extremely wide-angle lens to shoot the broad scene, or a very long lens to come in close on one or two carefully selected boats. In addition to what you'll find in the water, there are dozens of rowboats and kayaks on the beach—great subject matter for close-up shots once the early morning light becomes less interesting.

Owen Park Beach is also an excellent spot to launch a kayak and paddle around the harbor in search of photos. Without this ability to actually go out *in* the harbor itself, there is some frustration at the rather limited vantage points along the dock and beach. I keep one of my kayaks on the Owen Park Beach dinghy rack so that if the conditions are right, I can be out on the water at a moment's notice.

Directions: From the start of Main Street where the Mansion House is located, go 0.2 mile. On your right you'll see a small green-and-white sign, "Owen Little Way." Turn right, drive down the steep hill toward the harbor, and park.

26. William Street Historic District

Main Street, Vineyard Haven, is ideal for shopping and eating but not particularly interesting for photographers. The great fire of 1883 destroyed most of the buildings on Main Street and nearby, in the village then known as Holmes Hole. For this reason the architecture on Main Street is relatively new and uninteresting. You've got to walk a little farther afield to discover the older buildings in town, which were spared in the fire. Just up from Main Street is the William Street Historic District, where you can discover a handful of stately architectural gems. Many of the houses in this area were built by sea captains in the mid-to-late 1800s.

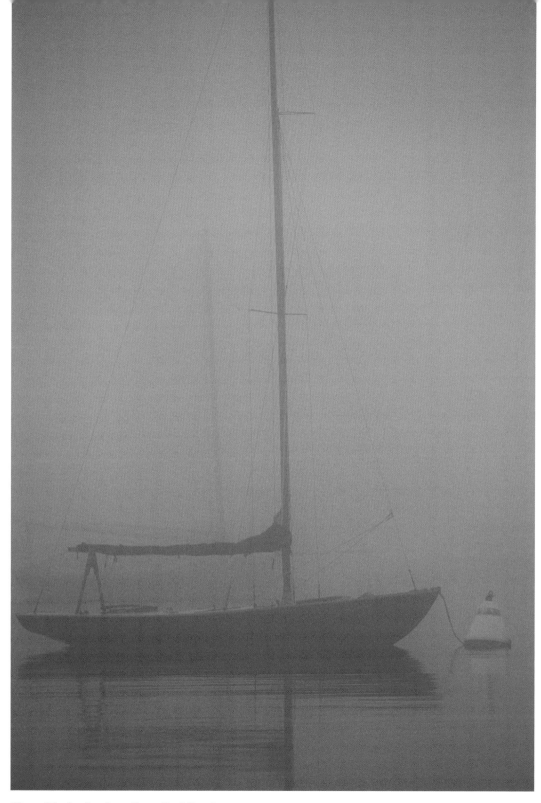

View of the harbor from Owen Park Beach

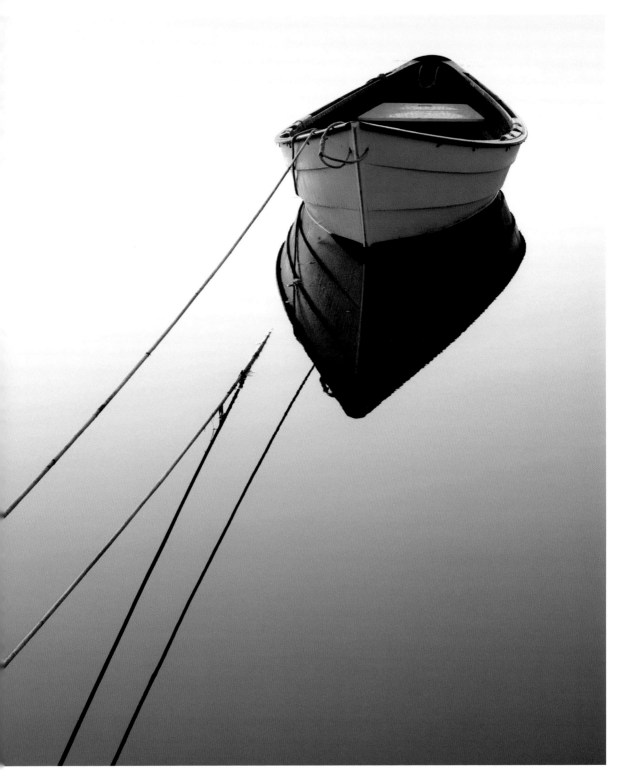

Lagoon Pond

Directions: The William Street Historic District centers around the intersection of Church and William streets, one block up from Main Street.

27. Lagoon Pond Park

Here you'll find a small stretch of beach, an active town landing and boat launch, and dozens of small boats pulled up on shore and larger boats moored in the Lagoon. This spot has really easy access, and you'll be able to tell from a drive-by whether you want to stop or not. There are a couple of pretty wooden dories that make their home here and it is a prime location for scallopers in the off-season. I love early mornings that are flat calm, ideally with a little mist or fog.

Directions: Lagoon Pond Park is located just beyond the Lagoon Pond Drawbridge on your left headed toward Vineyard Haven.

Non-photographic Diversions

Go for a spin around the harbor and beyond on one of the **Black Dog Tall Ships** (www.theblackdogtallships.com), the *Shenandoah* or *Alabama*. Enjoy the sail and watch the sun go down over Vineyard Sound.

Wind's Up (www.windsupmv.com) is a great place to rent a kayak or windsurfer and get out onto the water. If you choose to kayak, then by all means bring your camera, since the Lagoon is, in my view, one of the most interesting bodies of water to photograph.

Be sure to take a drive down Main Street and out to **West Chop**, an exclusive summer enclave dating back to the late 19th century. There's a lighthouse along the way, the **West Chop Light**, worth a look but difficult to photograph since it's on private property and surrounded by trees.

If you're in the mood for a plein-air cultural experience, take in a Shakespeare play at the

Kayaks, Wind's Up

Tisbury Amphitheater. The amphitheater is in an enchanted wooded grove a short walk down a well-trodden path from the Tashmoo Overlook. The performances are delightful and always seem to involve actors and actresses frolicking though the woods and popping out from behind trees. Bring a blanket, a picnic supper, and some bug spray. For an indoor, in-town theater experience, see a play at the **Vineyard Playhouse** (www.vineyardplayhouse.org), the island's only year-round professional theater.

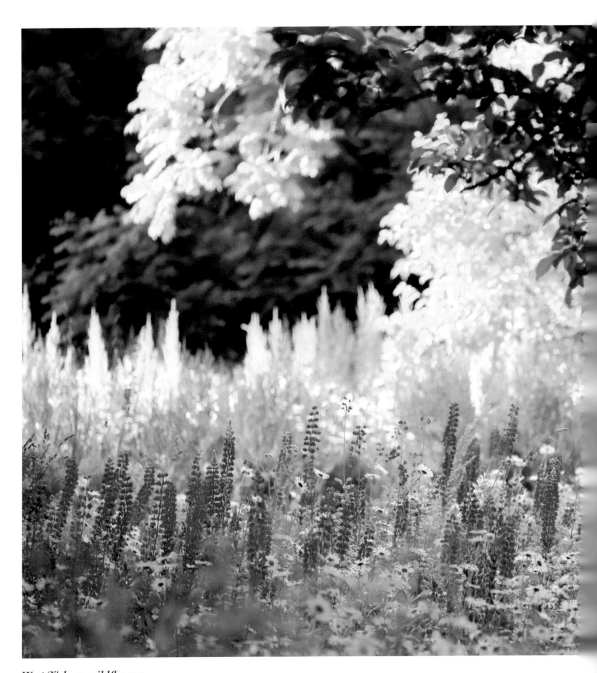

West Tisbury wildflowers

V. West Tisbury

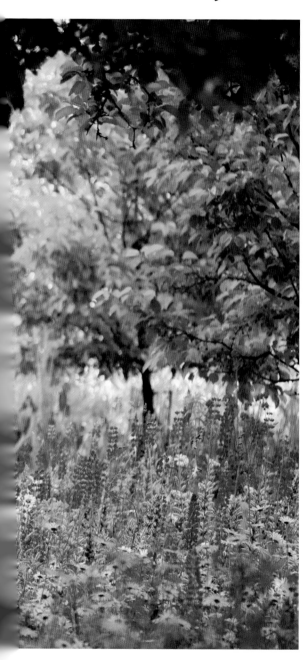

Where: Up-island, bordering on Chilmark to the west and Vineyard Haven to the east

Noted for: Agricultural land, picturesque village, general store, farmers' market, agricultural fair, beaches on both the sound and ocean side

Best Time: Fall for photographs, summer for vacation

Public Restrooms: At the Grange Hall

Sleeps and Eats: Very few. Eats concentrated in North Tisbury.

Sites Included: West Tisbury Village, Polly Hill Arboretum, Cedar Tree Neck Wildlife Sanctuary, Lambert's Cove Beach, Paul's Point, Makonikey Head, Long Point Wildlife Refuge

General Description: West Tisbury lies at the geographical center of the island. It is largely rural and agrarian, but boasts plenty of coastline as well, since it cuts through the island from the south to north shores. The village itself is like something out of a Norman Rockwell painting, with its white steepled church, grange hall, general store, imposing mansard-roofed town hall (formerly the schoolhouse), cemetery, and old mill building.

28. West Tisbury Village

The village of West Tisbury makes for a perfect stopover on your way up-island. It is picturesque and walkable, with a handful of architectural gems nestled in a rural setting that feels as if it could be many hundreds of miles from the sea.

Start your visit at **Alley's General Store**, "Dealers in Almost Everything," dating back to

1858 and the oldest operating retail business on the island. The store is loaded with quaintness and history. It's worth a stop as much for the experience as for the photos. Early mornings you are likely to find farmers, fishermen, and summer folk hanging out on the front porch, drinking coffee and exchanging local gossip.

Nearby is the stately white clapboard **First Congregational Church of West Tisbury**, perfectly framed by a white picket fence, brick sidewalk, and just the right trees. The clock in the church tower is still hand-wound and rings on the hour. The church stands at the corner of Music Street, named for the many pianos once found in the homes along the bucolic, tree-lined street. The story goes that in the days of whaling, Captain George A. Smith bought the first piano in town for his daughter. Not to be outdone, seven of his neighbors purchased pianos for their daughters as well.

Across the street is the **Field Gallery**, set amid a fanciful gathering of whimsical white statues created by the late West Tisbury sculp-

First Congregational Church

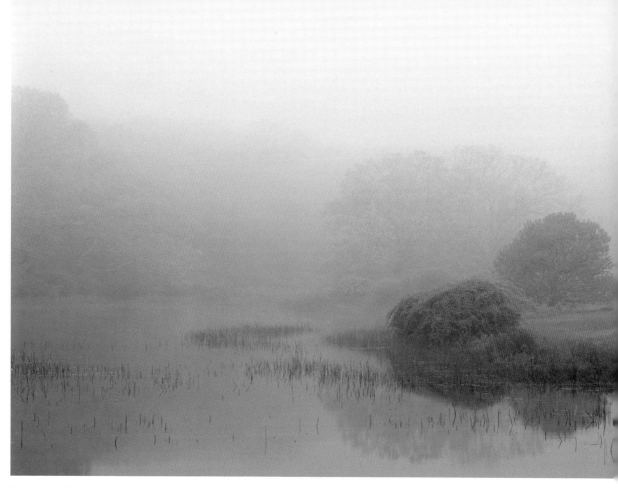

Parsonage Pond

tor and artist Tom Maley. Some of these over-sized nymphlike creatures are dancing, while others are playing musical instruments, and all are worthy of photos.

A couple of doors down from the church you'll find the **Grange Hall**, a grand post-and-beam barn originally constructed by the Martha's Vineyard Agricultural Society in 1859, and now owned by the Martha's Vineyard Preservation Trust. While the architecture itself is worthy of photographs, it's the twice-weekly Farmers' Market that draws me back again and again for pictures.

The **West Tisbury Cemetery** is worth a look—a quarter mile down-island on State Road, just beyond Parsonage Pond and Whiting Farm (both of which offer up pastoral views from the roadside). There are plenty of historically interesting gravestones in the cemetery, but one stands out due to its adornment with ornamental chickens. This is the grave of Nancy Luce, an eccentric West Tisbury poet from the mid-19th century, who lived alone with her cherished chickens. She made a living knitting socks and mittens for whale men and later selling her poems to curious tourists. Whenever a favorite hen died, she would write an elegy to it and mark its grave with a carved

Polly Hill Arboretum

headstone (some of which can be seen and photographed at the Martha's Vineyard Museum in Edgartown).

29. Polly Hill Arboretum

The arboretum (www.pollyhillarboretum.org) was founded by legendary horticulturist Polly Hill, who at the age of 50 began collecting and planting seeds gathered from around the world. She lived to be 100, so was able to enjoy the fruits of her labor—until nearly that age she could be seen charging around the arboretum in her trademark bright yellow cart.

Today the arboretum is a 70-acre nonprofit horticultural and botanical landmark, open daily to the public. Rare trees and shrubs are set among stone walls, meadows, a lovely old barn, and an antique homestead.

The site is especially photogenic during the late spring and early summer months, since the arboretum is known for Polly's famous North Tisbury azaleas, as well as rhododendrons and other flowering bushes and trees. Try to go early in the morning or in soft lighting conditions—overcast, fog, or light rain.

Directions: From Vineyard Haven, head up-island on State Road. Bear left at the intersection of North Road; the Arboretum entrance is 0.4 mile on your right.

30. Cedar Tree Neck Wildlife Sanctuary

Half the challenge here is to make it down the steep, winding, and deeply rutted dirt road with the underside of your car still intact. But

assuming you can get there, Cedar Tree Neck has lots to offer.

Cedar Tree Neck, a Sheriff's Meadow Foundation property, is largely a network of woodland trails, but it also offers streams, freshwater ponds, a sandy beach, hilly terrain, and all sorts of plants and critters. The beech forest is visually quite interesting for photographers. Beech trees have developed unique ways of keeping out other plants, including a root system close to or even above the surface to make it hard for other plants to grow. Young beech trees can sprout directly from these roots and are able to grow quickly, since they receive nutrients from the parent tree. The resulting grove of tightly knit windswept trees, interspersed with rocks and boulders left by the glacier, is one of the most unique and photogenic woodland settings on the island. Flat light is best for this subject matter—midday sun has far too much contrast.

Directions: From its intersection with State Road, follow Indian Hill Road for 1.3 miles. Turn right onto the Obed Daggett Road. Following the "Sanctuary" signs, take Obed Daggett Road 1.0 mile to its terminus at the Cedar Tree Neck trailhead and parking area.

Beech trees, Cedar Tree Neck

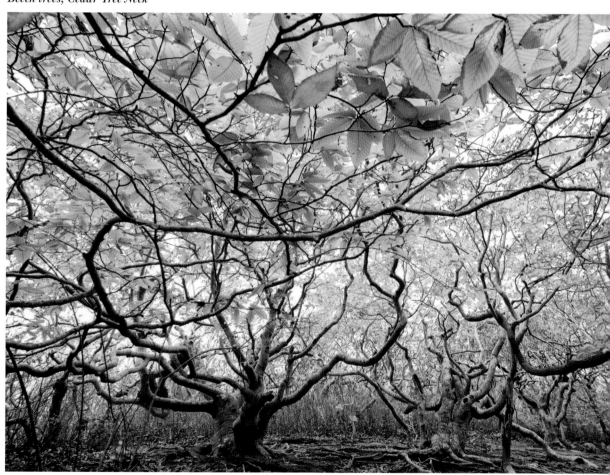

Lambert's Cove Beach

31. Lambert's Cove Beach
32. Paul's Point
33. Makonikey Head

Part of the charm of Lambert's Cove Beach is the walk to get there, down a quarter-mile sandy path, through the woods in the dappled sunlight. If you go in the summer, you'll know you're almost there when you see a pile of flip-flops and sneakers lined up along the fence. Add yours to the group and then walk up and over the steep dune to a sweeping view of the crescent-shaped white-sand beach. This higher elevation is the vantage point I most like, with beach grass in the foreground framing the view. If you climb a little higher still (be gentle with the dunes since they are fragile) and shoot to your left, James Pond will also be in your viewfinder as you take in the westward vista.

If you'd like to explore more of the north shore, you can walk from Lambert's Cove to two other locations that are worth photographing but have no other public access. These are Paul's Point, a mile to the west, and Makonikey Head, a little over a mile to the east. In the summertime, you may be impeded by beach guards, but in the off-season access will not be an issue. Both of these locations have rocks in the water to photograph, but a particular favorite of mine is Split Rock at Makonikey. Shortly before you reach Split Rock, you can climb up the steep wooden steps to the top of the cliffs for a bird's-eye view of Vineyard Sound.

Directions: Leaving Vineyard Haven on State Road, bear right onto Lambert's Cove Road, lower end. Go 2.7 miles and on the right side of the road you will see a small dirt parking lot bordered by a split-rail fence. Nonresidents can park here after hours in-season or anytime in the off-season.

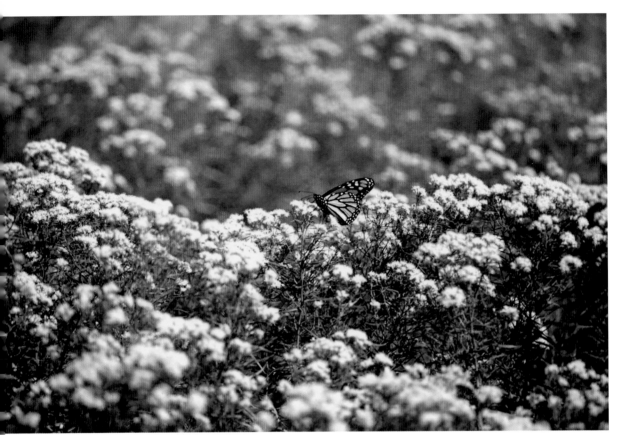

Long Point

34. Long Point Wildlife Refuge

Long Point is a 600-plus-acre tract of land on the island's south shore, managed by The Trustees of Reservations. The property includes a half mile of ocean beach, coastal ponds, woodland, miles of walking trails, and a most unique and photogenic broad sweep of sand plain heath. Long Point is a treasure trove for birdwatchers and nature lovers as well as for photographers.

Off-season is a better choice for photographers than the peak of summer—it's such a popular destination for beach-seeking vacationers that you practically have to set your alarm clock for the crack of dawn to arrive before the parking lot is full and closed for the day. My preference would be to wait for mid-September or later, when the light is more interesting, and you can focus on the scenery and not the beach-goers.

Directions: Mid-June through mid-September: Traveling west on Edgartown–West Tisbury Road, proceed 0.3 mile beyond the main entrance to airport. Turn left onto Waldron's Bottom Road and follow it for 1.3 miles. Turn left onto Scrubby Neck Road (Path), then right onto Hughes Thumb Road, and follow signs for 1.2 miles to the summer parking area.

Mid-September through mid-June: Traveling west on Edgartown–West Tisbury Road, proceed 1.1 miles beyond the main entrance to airport. Turn left onto Deep Bottom Road and follow it for 1.5 miles, always bearing left at forks. Turn right onto Thumb Point Road and go for 1.3 miles until you reach the off-season parking area.

Non-photographic Diversions

The **Granary Gallery** at the Red Barn (www .granarygallery.com), a destination in itself, is consistently voted the island's top art gallery. It's a big sprawling building crammed with art and antiques. Photo buffs will be especially pleased to find the work of *Life* magazine great Alfred Eisenstaedt, contemporary black-and-white photographer David Fokos, and some of my color and black-and-white prints.

Check out the **Martha's Vineyard Glassworks** (www.mvglassworks.com), where you can watch skilled glassblowers in action and purchase an exquisite example of their handiwork from the shop.

If you're in a shopping mood and are looking for locally produced crafts, the summer **Artisans Festivals** at the Grange Hall (www .vineyardartisans.com) are a must-do. Fabulous wares make for unique gifts.

Martha's Vineyard Glassworks

Menemsha

VI. Chilmark

General Description: As you head up-island into Chilmark, you are entering a landscape completely different from the flat terrain and densely populated towns of down-island. Chilmark's landscape is characterized by a hilly topography, crisscrossed with many miles of old stone walls, punctuated by the occasional glacial erratic, and decidedly rural in look and feel. In all of up-island, it is the rugged coastline and the natural beauty of the land that dominate, while the villages are relatively small in size.

In the center of Chilmark, within a stone's throw of Beetlebung Corner, are the town hall, fire station, police station, school, library, community center, bank, post office, general store, community church, and just a small handful of additional buildings. Chilmark is quiet in the wintertime, but it has a large summer population, a number of them both rich and famous, drawn to the town for its spectacular beaches and relative quiet and seclusion.

35. Quansoo Farm
36. Quansoo Preserve

Quansoo Farm (Sheriff's Meadow Foundation) and Quansoo Preserve (Land Bank) include over 150 acres of coastal sand plain and access to the Tisbury Great Pond. In the Wampanoag language, the name "Quansoo" means eel or long fish, and the name likely derives from the fall migration of female eels from Black Point Pond to the sea.

Until Quansoo Farm and Preserve were opened to the public just recently, there was no public access to the Chilmark side of the great pond—in fact, this area is so exclusive that a coveted key to the locked gate and a deeded

Where: Up-island between Aquinnah to the west and West Tisbury to the east
Noted for: Fishing village, ocean beaches, stone walls, woodland walks, farms
Best Time: Fall for photographs, summer for vacation
Public Restrooms: In Menemsha near Dutcher Dock
Sleeps and Eats: Only in-season. Eats are primarily in Menemsha and in the center of town.
Sites Included: Quansoo Farm, Quansoo Preserve, Middle Road, Lucy Vincent Beach, Quitsa Pond, Squibnocket Beach, Squibnocket Pond, Stonewall Beach, Menemsha, Menemsha Hills Reservation, Great Rock Bight Preserve, Waskosim's Rock Reservation

sliver of beach have regularly sold for over $300,000.

The property includes a maritime oak forest, sand plain grassland, coastal heathland, hayfields, resident ospreys, and the antique Mayhew-Hancock-Mitchell farmhouse, built in the mid-1600s and one of the oldest houses on the island. The preserve and farm stretch from the shores of Black Point Pond to the Tisbury Great Pond.

The most unique aspect of this property is the quality and quantity of grasslands and open vistas. Although my personal preference is for the fields and ponds, there are a few fabulously knotted and expressive old oak trees along the woodland trail.

Directions: Begin at the sign on State Road marking the West Tisbury–Chilmark town line. Continue up-island 0.5 mile and turn left

Quansoo Farm

onto Quansoo Road (a dirt road with a handful of mailboxes but no street sign). Once you turn onto Quansoo Road, follow the main road 1.4 miles to the trailhead (be careful to stay to the left at the 0.5-mile juncture with Quenames Road).

37. Middle Road

One of the most picturesque and rural roads on the island is Middle Road. It begins in West Tisbury, but most of it is located in Chilmark. I'm especially fond of its pastoral views—most very intimate, but others sweeping and grand. There is quite a variety of farm animals along this stretch of winding, hilly country road, including dairy cows, sheep, oxen, and horses. It's not a heavily traveled road, so it's fairly easy to simply pull over to the side of the road in a safe spot to photograph.

Starting from the West Tisbury end, you will pass **Brookside Farm** on the left, with its lush green fields, old stone walls, picture-perfect barn, and a couple of large Red Devon oxen (Bud and Boy) often grazing close to the road.

Directly opposite from Brookside Farm, on the right side of the road, is the **Mermaid Farm and Dairy** farm stand. It's run on the honor system, with a scale to weigh your produce and a cigar box to put your money in. In August, their heirloom tomatoes are a coveted delicacy to eat as well as to photograph.

As you approach the end of Middle Road, on your left side, you'll come to one of the prettiest vistas on the island, the **Keith Farm** overlook. A stone wall surrounds a large gently rolling field across which you can see a small pond, windswept stands of trees, and a large

herd of cows. In the distance is a glimpse of the Atlantic Ocean. This scene is so classically beautiful that if the light is right, I generally like to photograph it with a wide-angle lens, so I can take in as much of the sweep as possible.

Just before you reach Beetlebung Corner, on the left side is **Beetlebung Farm**, another small self-serve farm stand worth a stop.

The ideal light in which to capture these pastoral scenes is either diffuse early morning dewy light or on a foggy day. "Soft" is the key word here. The fog also adds a nice touch of atmospheric perspective.

Directions: Middle Road runs from Panhandle Road in West Tisbury to Beetlebung Corner in the village of Chilmark. I've taken you along the road in an east to west direction, but it is just as easily done starting from Beetlebung Corner and driving east.

38. Lucy Vincent Beach

My favorite beach to photograph is Lucy Vincent Beach, named after a town librarian from the 1800s. The beach is framed by dramatic rust-colored cliffs, and the shoreline is dotted with large boulders smoothed and shaped over time by the action of the pounding surf.

In the summertime, Lucy Vincent Beach is restricted to sticker-carrying residents and seasonal visitors. Without a beach sticker, you'd be

Keith Farm, Middle Road

lucky to get within a half mile of this beach, and speaking from experience, it's really not possible to beg or borrow one of these coveted stickers. In the off-season (September 15–June 15), there is no chain across the road and no guards on the beach. It is open for all to enjoy. And from the photographer's perspective, it is much more photogenic without the hoards of summer beach-goers (many of whom are naked, since Lucy Vincent is a "clothing-optional" beach).

Since the beach faces south, it is a great location for both early morning and late afternoon light. Sometimes when I am teaching a workshop I like to take my students there for a back-to-back sunset and sunrise, since they both produce wonderful photographs and yet are entirely different experiences. The natural inclination when photographing sunrise or sunset is to look in the direction of the sun—for photographers, it's like a giant visual magnet in the sky. But at Lucy Vincent Beach, with such a big sweep of south-facing shoreline, you find yourself looking both toward and away from the sunrise or sunset.

I especially enjoy photographing the waves as they break over the rocks, with either a fast shutter speed to freeze the wave action or a slow shutter speed to make the water look silky-smooth.

Directions: The entrance to Lucy Vincent Beach is nondescript and easy to miss—I suspect they keep it that way to make it harder to find. Headed up-island on State Road (which turns into South Road), set your trip odometer at Alley's General Store in West Tisbury. The turnoff to Lucy Vincent Beach is 4.3 miles after Alley's on the left. Immediately before you reach the turnoff, you will come to a rise in a hill, with an open field sweeping down to the ocean on your left. This is the **Allen Farm** overlook, and it's worth pulling over to take in

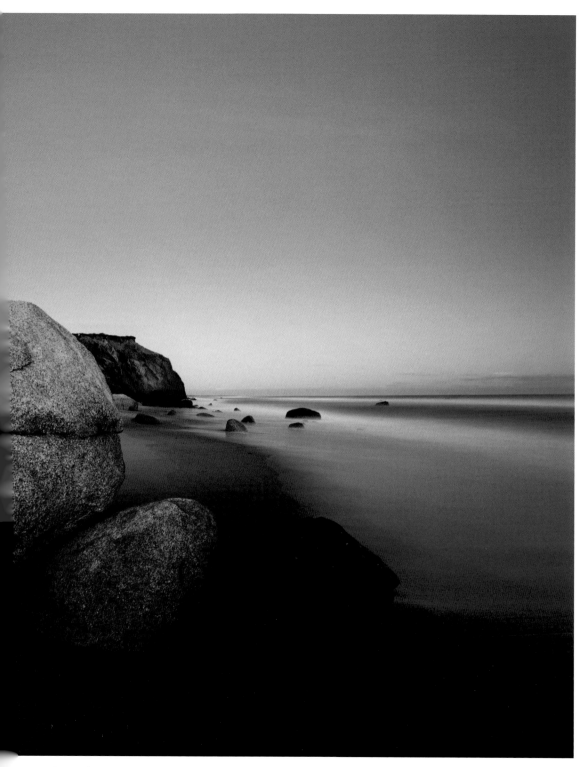

Lucy Vincent Beach

the view and maybe take a few photos as well if you find some cooperative sheep. From this point, the main road goes down a hill and curves sharply to the left. The entryway to Lucy Vincent Beach is a wide dirt road on your left, with a telephone pole right in the middle. There is no street sign. A couple of hundred yards down the dirt road to the beach, bear to the left. You'll pass a gatehouse on your right. Continue to the end of the road and park. From there, it's a short walk down a sandy path to the beach.

39. Quitsa Pond

The Quitsa Pond bridge and public landing is one of the few up-island locations with a great view of the water on both sides of the road. It's also a quick and easy stop to make along your way to Squibnocket Beach and Aquinnah. From the bridge, on your left is Stonewall Pond and beyond is Stonewall Beach. On your right is Quitsa Pond and beyond is Menemsha Pond. There is a little boat landing and dock. It's a pretty view from this point, looking north over Quitsa Pond in late afternoon light. Just to

Allen Farm

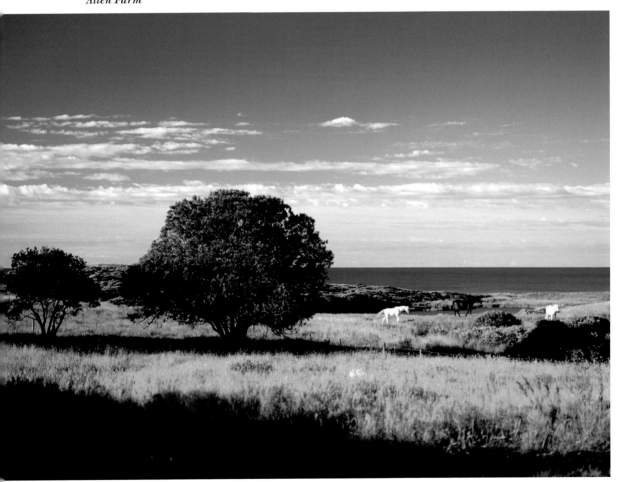

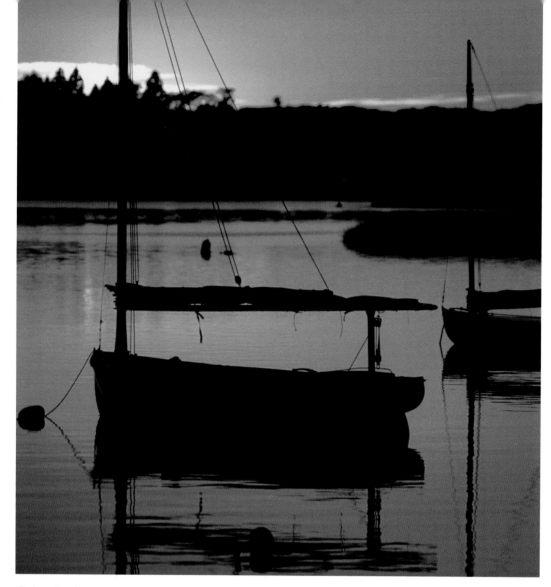

Quitsa Pond

the right is a small picturesque wooden boat-house, a favorite for photographers.

If you are a kayaker, this is a terrific place to launch your kayak and to explore the three ponds. My very stable Perception kayak, with its roomy cockpit, is a wonderful platform from which to photograph. I intentionally pick flat calm conditions because they make for better pictures (calm is best for reflections) and keep your equipment safe and dry. I also love the low vantage point afforded by the kayak. Most photographs of water, shoreline, and boats are taken from a standing eye-level height, but if you are photographing from a kayak, the perspective is quite close to sea level.

Directions: This location is hard to miss. It's on State Road a mile or so before crossing over

Stonewall Beach

into Aquinnah. You'll come down a long hill, at the bottom of which is a small bridge. On the far end of the bridge take a sharp right into a dirt parking lot where the town landing is located.

40. Squibnocket Beach
41. Squibnocket Pond
42. Stonewall Beach

A big plus about Squibnocket is its easy access. The beach is just a couple of feet away from where you park—in fact, it's a great vantage point from which to view and photograph a big ocean storm from the comfort of your car.

As with Lucy Vincent, if you are in season, it's a residents-only sticker beach. But unlike Lucy Vincent, after 5 PM in the summertime, the beach guards leave, and it is available for all to enjoy.

Although I find this beach to be less picturesque than Lucy Vincent, and the rocks along the shoreline are not as plentiful, it is still worth a stop. Also, when the conditions are right, Squibnocket is very popular with the surfing crowd, in the spring and fall as well as the summer. If you are interested in photographing the surfers, I would suggest either using a very long lens (at least 300mm) or being there in gorgeous light in which the surfers simply become small elements in an overall landscape photo.

Access to Squibnocket Pond is from the right side of the beach parking lot, down a narrow path lined with beach grass and phragmites. It's an easy place to launch your kayak.

A short walk down Squibnocket Beach to your left will bring you to one of the most unique beaches on the island, Stonewall Beach. The photographic possibilities are great, because, as its name implies, the beach is made up of a massive "wall" of smoothed and weathered beach stones.

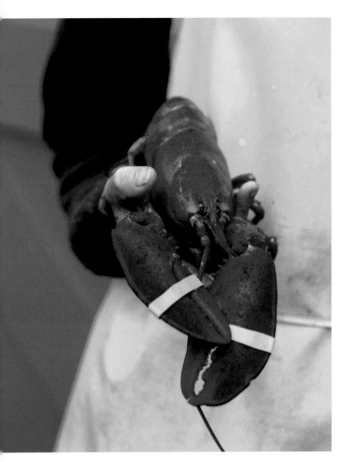

Larsens' Fish Market, Menemsha

There is no direct public access to Stonewall Beach, so walking from Squibnocket is the easiest way to get there. In the Commonwealth of Massachusetts, private landowners own to the low-water mark (as opposed to the high), so you are actually walking on private property, and you might not even make it all the way to Stonewall without encountering a beach guard. My suggestion would be to visit Stonewall Beach in the off-season, when all of the island beaches are much more available and walkable.

Directions: The turn-off to Squibnocket is 0.5 mile beyond the Quitsa Pond landing. The road doesn't have a street sign, but it will be the first paved road on your left. It's a short drive down to a big dirt parking lot overlooking the beach.

43. Menemsha

Menemsha is a picturesque working fishing village and harbor—probably the number-one destination on the island for photographers. There's a lot here to take pictures of—fishing boats, docks, lobster traps, reflections, fish markets, surf casters, fishing shacks, and piles of junk.

During the summer, Menemsha is the island's premier sunset location, and you should feel like you've won the lottery if you manage to snag a parking spot any time after 4 PM. It is the sort of place where everyone cheers when the setting sun hits the horizon, flashbulbs popping in an attempt to capture that moment (an obviously misguided attempt, since flash will not touch the distant sun and water).

Despite the summer crowds at sunset, this is still the right time of day for photographing Menemsha, regardless of the season. The warm late afternoon light bathes everything in a wonderful orange glow, and once the sun gets near the horizon there are all kinds of subjects to photograph in silhouette.

I usually try to get to Menemsha several hours before sunset. I suggest starting your visit on the left side of the harbor where the general store is located. Among my favorite subjects are the reflections of docks and boats in the inner harbor, the window of one particular fishing shack, and the traditional wooden fishing boat *Little Lady*. The 75-year old dragger sits alongside a dock in the harbor to your right. When I was a ten-year-old kid, I used to draw pen-and-ink sketches of the *Little Lady,* tied up to the dock in the exact same spot where you'll find her today. She has been

Dutcher Dock, Menemsha

worked and loved by two generations of the Jason family, and she still fishes for fluke in the summertime. *Little Lady* is dark green with a bright orange dory atop her deckhouse, and she's quintessentially Menemsha.

For the actual setting of the sun, I drive around to the other side of the harbor to Dutcher Dock. If it is summer and you don't want to deal with the hassle of re-parking your car, there's a walking shortcut on Harbor Hill Road right next to the general store—the road ends near the top of the hill, but the walking right-of-way continues up over the crest of the hill and rejoins the road on the other side.

The ideal location from which to watch the sun go down over Vineyard Sound is Menemsha Beach and the jetty at the entrance to Menemsha Harbor. I especially like to photograph the fishermen on the end of the jetty and any boats entering or exiting the harbor. Since you are looking in the direction of the setting sun, there are wonderful opportunities for photographing the action as back-lit silhouettes.

A lesson my workshop students often learn at Menemsha is the importance of staying at a sunset location until you run out of light. I can't tell you the number of times I've watched the sun set and seen everybody (photographers and non-photographers alike) pack up their stuff and head home. And then, a good half hour after sunset, the colors start getting more and more saturated, with an intense orange glow at the horizon.

Directions: Menemsha is at the very end of North Road. As you approach the village, you will drive down a steep hill. Go straight until the road ends at the harbor, and park anywhere in front of the Menemsha General Store and Galley Snack Bar. Later in the afternoon you can walk or drive over to the other side of the harbor, following the sign for Dutcher Dock.

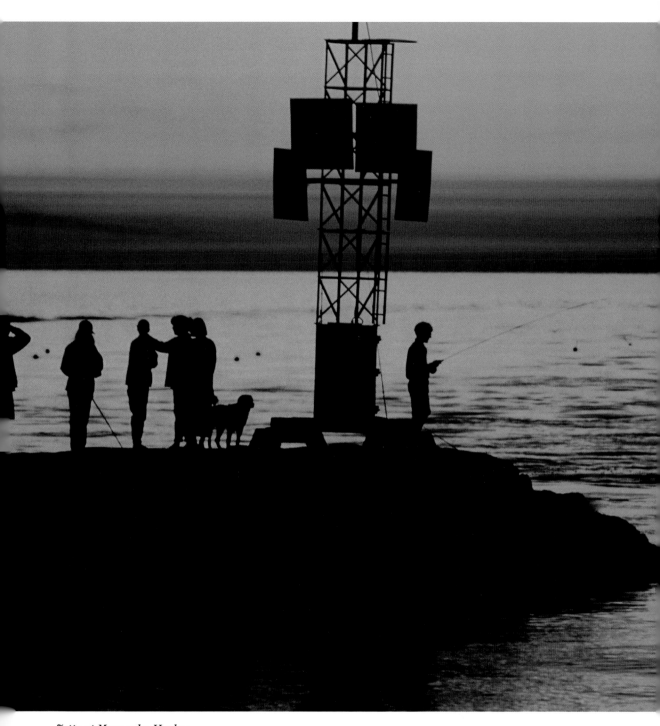

Jetty at Menemsha Harbor

Great Rock Bight

44. Menemsha Hills Reservation
45. Great Rock Bight Preserve

Menemsha Hills (Trustees of Reservations) and Great Rock Bight (Land Bank) are both conservation land, with well-marked trails through the woods that lead to sweeping views of Vineyard Sound and eventually make their way down to the rocky beach along the island's north shore. Both are rather remote, so you'll feel as if you've got the place pretty much to yourself. Great Rock Bight is named after a big boulder situated in a "bight," which is another name for a "bay." Allow plenty of time for Menemsha Hills, since it's a long hike to the shore—along the way you'll come to an observation deck with stunning views.

Both beaches face northwest, so afternoons are the best time to go. Vineyard Sound is a sheltered body of water, so unlike on the south shore, the wave size is generally modest. Wear good hiking shoes, for the trails can be steep and rutted.

Directions: Menemsha Hills and Great Rock Bight are located on North Road, with their entrances within a mile of each other. Leaving Menemsha, go up the big hill and continue straight on North Road for 1.5 miles to the entrance to Menemsha Hills (small green sign) on the left side of the road. Another mile down the road on the same side is the entrance to Great Rock Bight (small white sign).

A little farther along North Road headed down-island, you'll find a bright red old abandoned gas pump by the side of the road, which appeals to photographers and painters alike.

46. Waskosim's Rock Reservation

Straddling the border between Chilmark and West Tisbury, Waskosim's Rock Reservation, at 185 acres, is one of the largest tracts of land owned by the Martha's Vineyard Land Bank. Waskosim means "new stone" in Wampanoag, and the property is named after the giant boulder that marked the boundary between the English and the Wampanoag lands in the 17th century. It is 14 feet high and twice as long, has a deep crack running through it, and is located at the base of the reservation's highest hill.

The miles of trails meander along a brook, past ancient stone walls, through woodlands, wetlands, and fields.

Directions: The turnoff for Waskosim's Rock Reservation is on your right side 4.6 miles from Menemsha. Look for a small Land Bank sign. Immediately beyond the turnoff is the town line for West Tisbury.

Non-photographic Diversions

Chilmark Chocolates would be worth the trip from anywhere on the island, so there's no excuse not to stop if you are driving by. I love the chocolate truffles and dark chocolate butter crunch best of all. There can be long lines in the summertime, but it's worth the wait. They are located on the right side of the road headed up-island, just past the police station. Their hours are limited, so for info call 508-645-3013.

Larsen's Fish Market (www.larsensfish market.com) is on Dutcher Dock in Menemsha. The Larsen family will boil your lobster to order, and you can sit outside overlooking the dock and harbor, or spread your blanket out on the nearby beach. Bring a bottle of wine to accompany your lobster (BYOB, since Chilmark is a dry town), and watch the fishing boats unload their catch and the sun set over Vineyard Sound. Come early, or you may still be in line by the time the sun goes down.

Waskosim's Rock

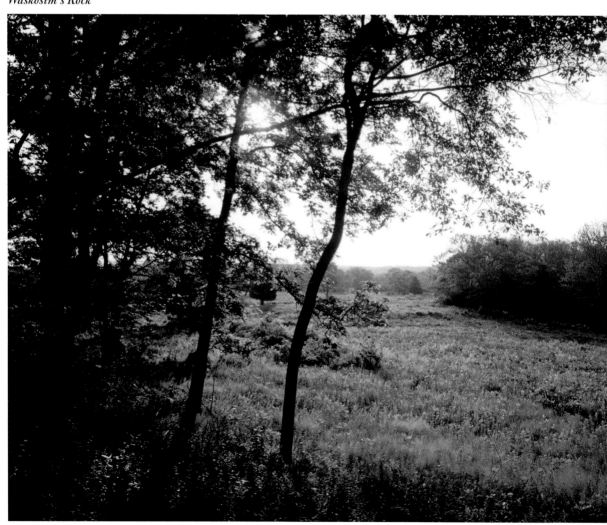

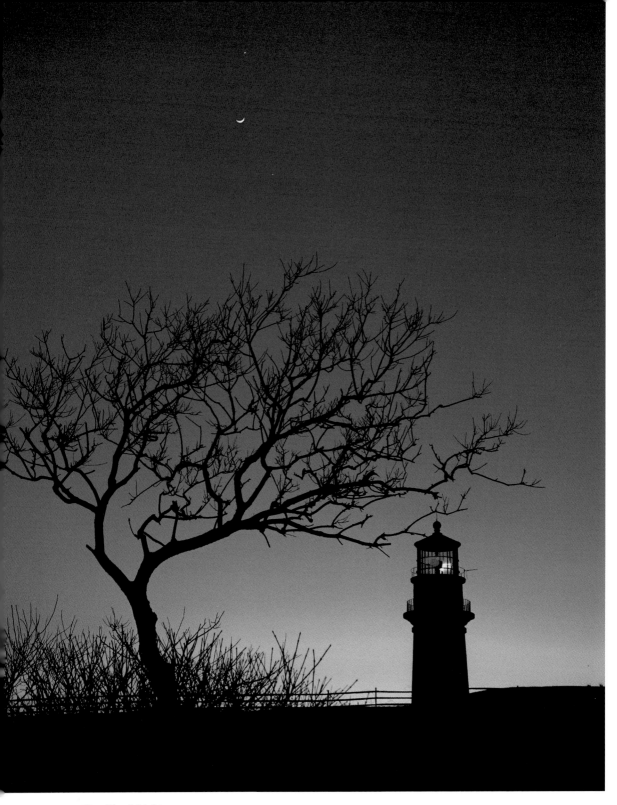

Gay Head Light

VII. Aquinnah

General Description: Aquinnah (formerly Gay Head—the name was changed to Aquinnah in 1997 by a popular vote of 79–76) is the westernmost town on the island and is geologically the most dramatic. As the last big glacier retreated northward 15,000 years ago, it left behind boulders, sand, and a spectacular and colorful clay headland jutting out into the sea.

Aquinnah is home to the Wampanoag Tribe, a federally recognized Native American tribe—about a third of the town's nearly 500 residents are of Wampanoag descent. This is one of the earliest sites of whaling, done from the shore by Wampanoags in small boats long before the 19th-century heyday of the whaling industry.

The town itself is modest, consisting of the town hall, police and fire stations, the library, and a church.

47. Gay Head Cliffs
48. Gay Head Lighthouse

Probably the most photographed scene on the island is the Gay Head Cliffs in Aquinnah, usually captured with the Gay Head Lighthouse standing sentinel along the right-hand edge of the frame. The cliffs and lighthouse have been popular destinations since the late 1800s, when visitors arrived at Gay Head by boat and were transported by oxcart to dine on lobster in one of the many restaurants, and to view the famous cliffs and the brick lighthouse with its Fresnel lens lit by whale oil.

The best place to shoot the classic view is from the viewing area atop the cliffs. If the day is too average, the sky too sunny, the hour too midday, then you will be pretty much assured of a trite "postcard" version of the scene. If that's what you want, then go for it. But if you'd

Where: Up-island, at the far western end
Noted for: Clay cliffs, lighthouse, ocean beaches, home to a Native American tribe
Best Time: Fall for photographs, summer for vacation
Public Restrooms: Near the parking area for the cliffs
Sleeps and Eats: Only in-season. Eats are near the cliffs.
Sites Included: Gay Head Cliffs, Gay Head Lighthouse, Moshup Beach, Philbin Beach

Gay Head Cliffs

like something more, that's where you need to pay close attention to weather conditions, lighting, and time of day. I find the most evocative view of the cliffs is at dusk, when there is color in the sky and you can see the light in the lighthouse. The lamp rotates and alternates between a red and a white light, so time your exposure so that you've got the more dramatic red light punctuating your image.

In season, the lighthouse is open to the public for a modest fee several evenings a week. If the weather and sunset cooperate, the view from the top should be breathtaking. The Martha's Vineyard Museum is the steward of the Gay Head Lighthouse—check out their website (www.mvmuseum.org) for info on visiting days and hours.

Directions: Follow State Road up-island, until the road ends in a loop at the lighthouse. There are a handful of parking spaces along the road opposite the steps that lead up to the concessions and viewing area.

49. Moshup Beach

This Land Bank location involves a bit of a hike, but it is one of the prettiest walks on the island and the best way to get down to the beach at the base of the cliffs. The path from the parking lot will lead you east and away from the cliffs—once you reach the beach, you can turn right and walk back toward the cliffs. Late afternoon is my favorite time of day, when the light casts a warm glow on the red, orange, yellow ochre, and white clay.

The Gay Head Cliffs have eroded dramatically over time. If you look at older photos of the cliffs, you will marvel at the variety and intensity of the color of the clay. Even in my own photos from twenty years ago the cliffs are more colorful than they appear today.

Directions: Follow State Road up-island, until the road nears the end and you can see the

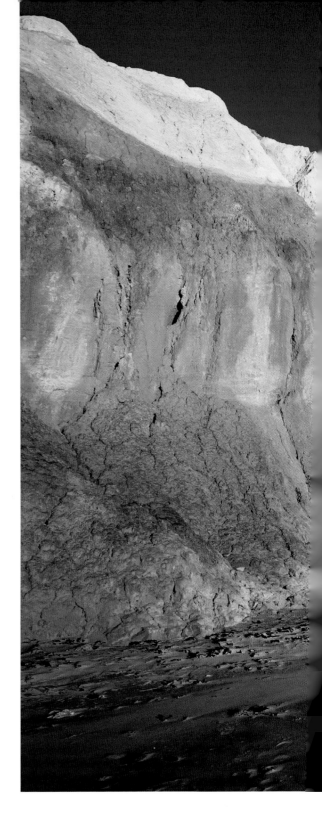

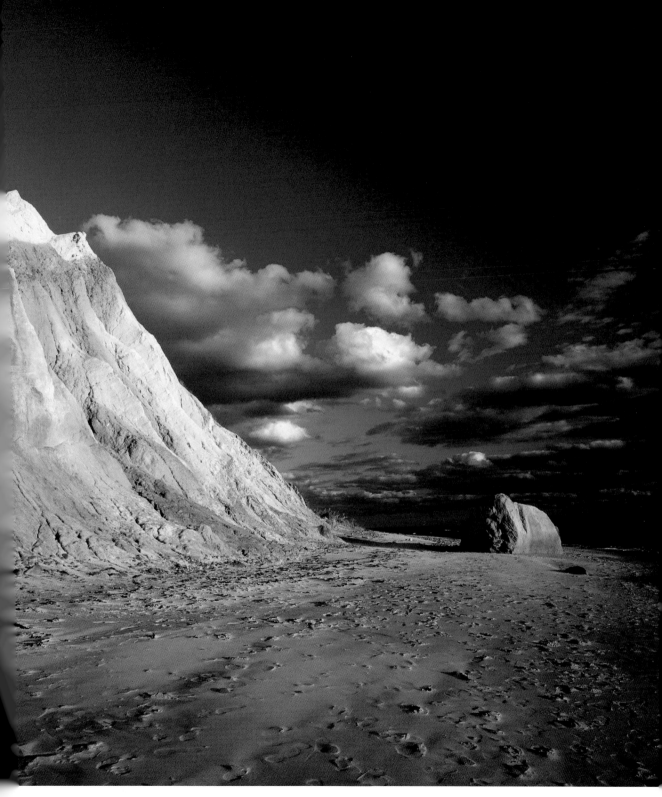

Gay Head Cliffs

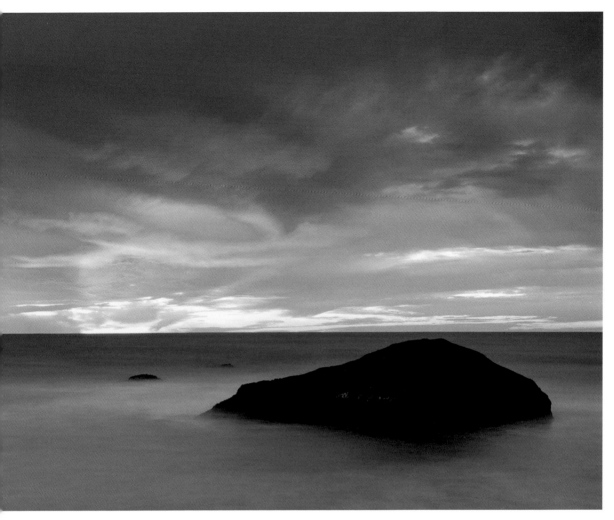

Moshup Beach

lighthouse at the top of the hill. Turn left onto Moshup Trail and take then an immediate right into a big dirt parking lot. In-season, they will charge you $15 to park, but it's worth the price of admission.

50. Philbin Beach

What I like best about Philbin Beach is the path up and over the giant sand dune on your way to the beach. The view from the top is truly spectacular, particularly if you're there

late afternoon, with heavy surf below and high clouds aloft. Once you're down the far side of the dune, the beach itself is pretty much a continuation of Moshup Beach. In the summer season Philbin Beach is open only to residents of Aquinnah—the rest of the year it is accessible to all.

Directions: Take State Road up-island. Once you cross the town line from Chilmark into Aquinnah, proceed 0.5 mile and turn left onto Moshup Trail. Follow Moshup Trail 2.4 miles

and the turnoff will be on the left. Immediately before you come to it, you'll pass Old South Road on your right. The entrance to Philbin Beach is marked by a large white sign with black letters, tucked into the bushes to the left of the entrance to the parking lot.

Non-photographic Diversions

A quintessential island event is the weekly community **Pizza Night at the Orange Peel Bakery** on State Road near the turnoff to Lobsterville. Proprietor Julie Vanderhoop cooks the pizzas in a 10-foot wide outdoor stone oven. She provides the crust, sauce, and cheese. Guests chip in $10 and bring a topping of their choice, plus a bottle of wine and/or a musical instrument if they're so inclined. Pizza Night happens in-season on Wednesday nights starting at 5 PM and lasting until the pizza dough runs out. For info, you can find them on Facebook.

Philbin Beach

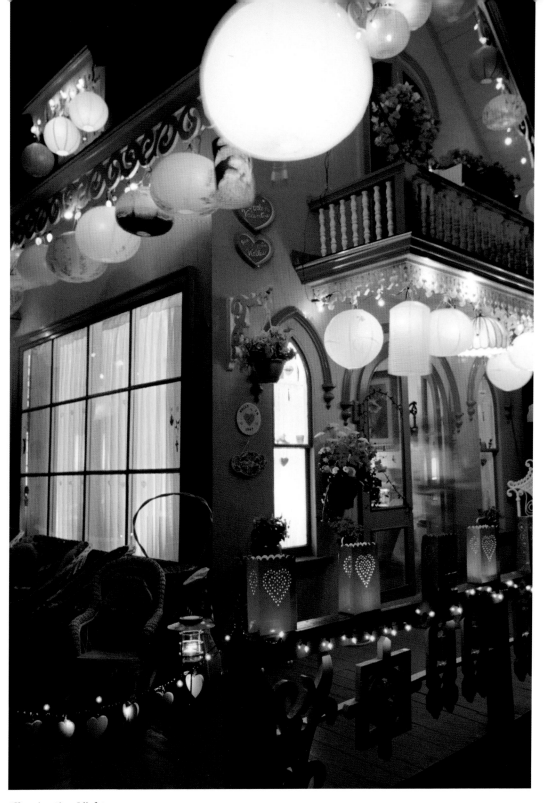

Illumination Night

West Tisbury Farmers' Market

West Tisbury Farmers' Market (www.west tisburyfarmersmarket.com) is a sure bet for photographers. The combination of the brightly colored floral bouquets, freshly harvested produce, the savory edibles, and Saturday's musical fare all combine to truly create a feast "for all the senses." Old pickup trucks, red-checkered tablecloths, and the Grange Hall make for a great setting. All you have to do is show up and hope for overcast skies—or even better, a light drizzle, which not only improves the photographic conditions but also diminishes the crowd. Shallow depth of field is preferable for capturing the feel of the array of offerings. A tripod is useful but not necessary, and can be a liability in the often-crowded conditions, especially if you are also juggling a Vietnamese cold roll and glass of freshly squeezed orange juice. The market happens on Saturdays and Wednesdays from June to October.

Illumination Night

Once each summer, generally the third Wednesday in August, the gingerbread cottages in the campgrounds in Oak Bluffs are festooned with paper lanterns on the night of the Grand Illumination. It is one of the most anticipated events of the summer, and dates back to the late 1860s. After a traditional sing-along in the Tabernacle (as in, "My hat it has three corners. . . ."), the lanterns in the park and on each of the cottages are lit simultaneously, to the gasps and cheers of onlookers.

For the photographer, Illumination Night is a great photo opportunity but also one fraught with challenges. Since the lanterns only remain lit for a couple of hours at most, you need to have a game plan and be ready to hit the ground running. A tripod is pretty important, although a pain to lug around and to set up. I'd also recommend a flashlight, to help you check your camera settings and also to pop some extra light into dark areas of your scene. Other than that, travel as light as possible, since the crowds are shoulder-to-shoulder all evening. Whatever you do, do not plan on combining

West Tisbury Farmers' Market

family time with photo time—arrange to rendezvous with them once the evening's festivities are over.

If the weather gods cooperate, it will be a flat calm evening—on a windy night, I might even give up on the photo idea altogether and do the family thing instead, since windswept lanterns present a nearly insurmountable challenge. If there's a particular house you'd like to shoot, such as the popular "Pink House," be ready and waiting when the lights go on, so that you've got a crack at it before the crowds descend. The biggest concentration of onlookers will be walking the main circle around the Tabernacle. There are also hundreds of cottages that fan out a little farther, and I often find it's worth it to explore the outskirts of the campgrounds in order to avoid some of the jostle of humanity.

A few technical pointers: With your camera on a tripod, be sure to use your cable release so that you don't move your camera when you depress the shutter. If you choose to go tripodless, pick a lens with image stabilization, which will allow you to hand-hold your camera at slower shutter speeds. Be sure your flash is turned off, unless you'd like to use a touch of fill-flash. If you are shooting RAW, white balance should be on Auto. If you are shooting JPEG, white balance should be on Auto, Shade, or Cloudy, but never Incandescent or Tungsten. An incandescent setting will turn the magical yellow-orange glow of the lanterns to a decidedly unmagical pure white light.

If there is any breeze at all, you need to be concerned with your shutter speed—your goal is to shoot at a fast enough speed to eliminate the motion of the lanterns. First try waiting for the moment that the wind "stops to take a breath" before pressing your shutter. If the breeze doesn't cooperate and the lanterns don't stop swaying, determine what is the slowest shutter speed you can get away with in order to minimize the motion—1/60 second should work for most conditions.

Ocean Park Fireworks

This is consistently one of the best fireworks displays you will see anywhere, anytime. The fireworks usually take place on the third Friday in August, as a sort of a grand finale to the summer season.

Although Ocean Park transforms into a sea of humanity for this event, you'll be pleasantly surprised to find that the best vantage point for photographers will be virtually devoid of spectators. This is the area directly behind the bandstand—although the bandstand blocks your view of some of the fireworks, it simultaneously provides a great foreground for the display. The biggest problem with most fireworks photos done by amateur photographers is that there is no subject matter except for the fireworks themselves.

Set up your tripod (yes, this is a "must") directly behind the bandstand, positioning the height of your camera so that some of the fireworks burst directly behind the bandstand in such a way as to silhouette its shape.

Once you get the hang of it, fireworks can be exceedingly simple to photograph. All you need is your tripod, a cable release, a black square of cardboard, some understanding of the "bulb" setting on your camera, and the ability to shoot in manual exposure.

The first thing you need to determine is your aperture. As a starting point, try f-8 at 200 ISO. With your shutter speed on bulb, leave your shutter open for the duration of the burst(s), typically anywhere from two to thirty seconds. Now examine your histogram on your camera's LCD to be sure you've got a good exposure.

In terms of shutter speed, the bulb setting allows you to manually determine the length of time your shutter stays open. Your goal is to keep your shutter open for as long as there are

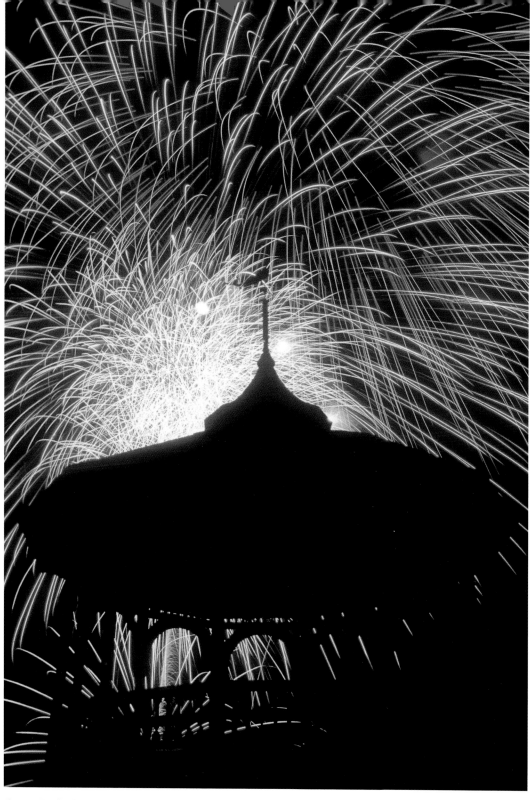

Ocean Park Fireworks

interesting bursts that occur in slightly varying locations in the night sky.

You may be wondering when the black square of cardboard comes into play. I use it to block out my lens while my shutter is open, either between bursts and/or if there's a burst I'd prefer not to have in my photo. Why not use a lens cap to accomplish the same thing? Because taking a lens cap on and off during an exposure is a fussy procedure and one that could cause your camera to move slightly.

Martha's Vineyard Agricultural Society Livestock Show and Fair

The fair is a four-day event (Thursday–Sunday) that generally occurs the third week in August. It is celebrating its 150th anniversary in 2011.

There's obviously a lot to photograph at the fair, but most appealing to me are the animals, the homegrown vegetables and flowers in the exhibit hall, and the midway and rides at dusk. You'll also find a woodsmen's competition, draft horse and oxen pull, piglet racing, women's skillet throw, oyster shucking contest, and a fiber arts tent.

During the day I don't carry a tripod and a lot of gear, since it would slow me down and wear me out. If I'm photographing people or animals, I usually shoot with a longer lens and a wide-open aperture. If I'm photographing the midway at dusk, it's helpful to have a tripod in the low light. I like to use a wide-angle lens to include the deep-colored sky and a slower

Prize-winning sunflowers, Agricultural Fair

Striped bass, Menemsha

shutter speed to emphasize the motion of the rides.

Of course no trip to the fair would be complete without sampling the MVRHS Touchdown Club's tempura, a cheeseburger from the West Tisbury volunteer firemen, and Everett Whiting's BBQ pulled pork sandwich.

Martha's Vineyard Striped Bass and Bluefish Derby

The annual fishing derby (www.mvderby.com) runs from mid-September to mid-October, when the island is awash with fishermen. They'll be found early and late at such spots as the Edgartown Lighthouse, Wasque, Lobsterville, Squibnocket, the Edgartown Bridge, and at many secret spots which are only talked about in hushed voices at the local tackle shops.

The fishermen serve as handy models for photographers, turning an otherwise deserted beach into a tableau or background for the lone surfcaster. Add some early morning or late afternoon light, and your resulting photo might be a keeper.

If you decide to silhouette a fisherman against a dawn or dusk sky, there are a few things to be aware of. Try to get the peak of the action as they cast, and look for a graceful silhouette where you don't have merging shapes. A profile shot of a baseball-cap-wearing fisherman is ideal. Dark apparel is better than light, since those tones are easier to silhouette.

Once you're in off the beach, be sure to check out the derby headquarters and weigh-in station on the waterfront near the Edgartown Yacht Club, open every morning 8–10 AM and every evening 8–10 PM.

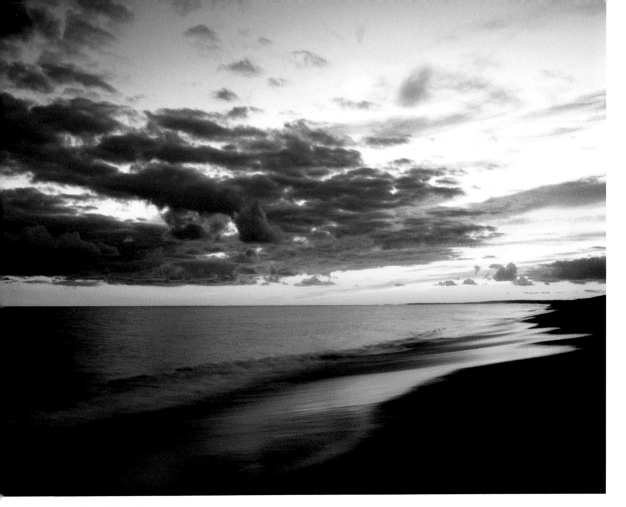

South Beach

Resources

Island Info

The Martha's Vineyard Chamber of Commerce (www.mvy.com) is the best source of info on lodging, events, getting around, activities, maps and general info.

Ferries

There are lots of choices of ferry service to the island in-season, but the only one that takes cars and operates year round is the Steamship Authority (www.steamshipauthority.com).

Conservation Lands

Martha's Vineyard Land Bank; www.mvland bank.com

The Trustees of Reservations; www.the trustees.org

Sheriff's Meadow Foundation; www.sheriffs meadow.org

Mass Audubon (Felix Neck Wildlife Sanctuary); www.massaudubon.org

The free Conservation Lands Map published by the Martha's Vineyard Land Bank is an invaluable resource for finding your way to the public lands on Martha's Vineyard.

Sunrise/Sunset Info

Including twilight and phases of the moon; www.photoephemeris.com

Photography Workshops

Alison Shaw Photography Workshops, featuring week-long workshops on the island; www.alisonshaw.com

Photo Supplies, Processing

Mosher Photo, Vineyard Haven; www.mosher photo.com

Bookstores

Looking for some photographic inspiration and ideas? There's no better place than a local bookstore.

Bunch of Grapes Bookstore, Vineyard Haven; www.bunchofgrapes.com

Edgartown Books, Edgartown; www.edgar townbooks.net

Martha's Vineyard Museum Shop, Edgartown; www.marthasvineyardhistory .org/shop.php

Eats

VERY Early Morning Coffee

Humphrey's, Vineyard Haven (open at 5 AM)
Cumberland Farms, Vineyard Haven (5 AM)
Dippin Donuts, Edgartown (5 AM)
Black Dog Bakery, Vineyard Haven (5:30 AM)

Mocha Motts, Oak Bluffs and Vineyard Haven (6 AM)

Breakfast

Aquinnah Shop Restaurant, Aquinnah (overlooking the ocean near the cliffs)
Artcliff Diner, Vineyard Haven (imaginative offerings)
Black Dog Tavern, Vineyard Haven (great atmosphere and views of the harbor)
Edgartown Inn, Edgartown (charming, old fashioned)
Linda Jean's Restaurant, Oak Bluffs (local favorite)
Right Fork Diner, Edgartown (watch the biplanes on the grass airstrip)

Lunch

The Galley, Menemsha (simple beach fare, harbor view from their small deck)
Humphrey's, Vineyard Haven (the Vineyard's best sandwiches to go)
Little House Café, Vineyard Haven (homey spot, try the fish tacos)
State Road Restaurant, West Tisbury (also excellent for breakfast, dinner)
Waterside Market, Vineyard Haven (popular spot for a quick lunch in-town)

Dinner

Flatbread Pizza, at the Airport (awesome pizza, OK atmosphere)
Henry's at the Harbor View Hotel, Edgartown (try their "small plates")
Nancy's, Oak Bluffs (watch the sun go down over the harbor)
Offshore Ale, Oak Bluffs (brew pub with excellent fare)
Sharky's Cantina, Oak Bluffs (great Mexican food and atmosphere)
Sidecar, Oak Bluffs (local neighborhood bistro)
Sweet Life Café, Oak Bluffs (fine dining, and a favorite of President Obama's)

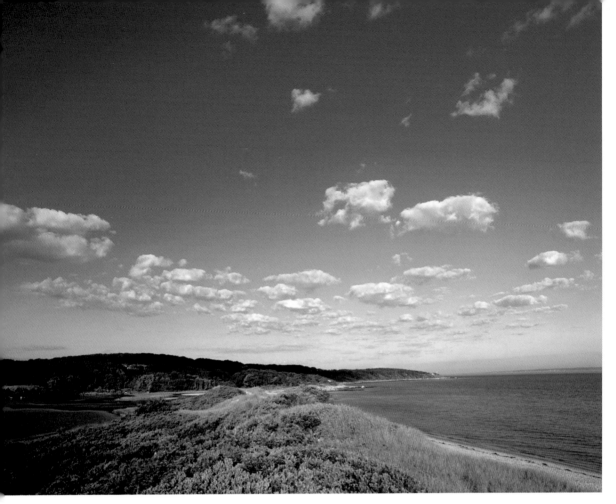

Lambert's Cove Beach

Favorites

Beaches

Lucy Vincent Beach
Wasque
Lambert's Cove Beach
Moshup Beach

Lighthouses

Edgartown Lighthouse
Gay Head Lighthouse

Sunrise Locations

Edgartown Lighthouse
Vineyard Haven Harbor
Lucy Vincent Beach

Sunset Locations

Menemsha
Lucy Vincent Beach

Picture-perfect Postcard Locations

Ocean Park, Oak Bluffs
Overlook at the Gay Head Cliffs
View from the Town Dock, Edgartown

Places to Explore with your Kayak

Chilmark Pond (launch from Chilmark Pond
 Preserve)
Tisbury Great Pond, West Tisbury (launch
 from Sepiessa Point Reservation)
Vineyard Haven Harbor (launch from Owen
 Park Beach)

Quitsa Pond, Menemsha Pond and Stonewall
 Pond, Chilmark (launch from Quitsa Pond
 public landing)
Edgartown Great Pond (launch from
 Meshacket Cove public landing)
Poucha Pond and Cape Poge Bay,
 Chappaquiddick (launch from Dike
 Bridge)
Lake Tashmoo, Vineyard Haven (launch from
 Lake Street public landing)

Harbors

Menemsha (working fishing harbor)
Edgartown (pleasure boats, lighthouse)
Vineyard Haven (wooden boats, ferry dock)

Edgartown Regatta

Flowers and Farm Stands

Edgartown Village (formal and cottage gardens)

Polly Hill Arboretum (horticultural and botanical center)

Mytoi (Japanese gardens)

West Tisbury Farmers' Market

Morning Glory Farm (farm stand)

Gingerbread cottages, the campgrounds

West Tisbury Farmers' Market

Architecture

Edgartown Village

Martha's Vineyard Camp Meeting Association gingerbread houses

Scenic Drives

Moshup Trail, Aquinnah

Beach Road, from Oak Bluffs to Edgartown

South Road, from West Tisbury to Chilmark

State Road, from Chilmark to Aquinnah

Middle Road, from West Tisbury to Chilmark

Nature Preserves

Felix Neck Wildlife Refuge

Long Point Wildlife Refuge

Cedar Tree Neck Wildlife Sanctuary

Quansoo Preserve and Quansoo Farm